STEAMPUNKERY

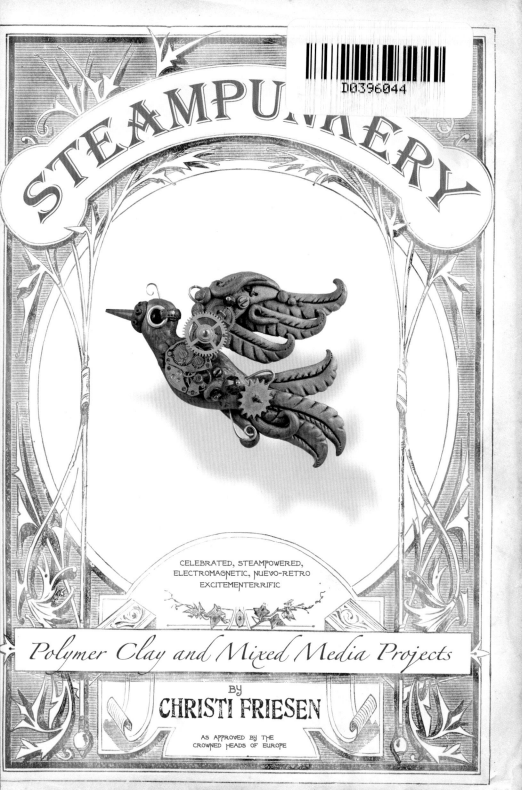

CELEBRATED, STEAMPOWERED,
ELECTROMAGNETIC, NUEVO-RETRO
EXCITEMENTERRIFIC

Polymer Clay and Mixed Media Projects

BY
CHRISTI FRIESEN

AS APPROVED BY THE
CROWNED HEADS OF EUROPE

2 CONTENTS OF THIS VOLUME

I chose

X
Alc
nev
mo
they

Stea
Proje
idea.
books,
interesti
draw fro

Anyway, here
projects. Along
play with a new n

FROM THE DESK OF PROFESSOR CONTRAPTION

Ah, such swellings of pride and also, indeed, of humble responsibility, do I feel at being able to assist in the production of this volume. You might wonder at such contradictory impulses tumbling inside my brain, nay! my very soul! But it is easily explained. I have spent a lifetime in the contemplation of the art of 'Steampunk' and to that end have devoted myself to further higher studies, being a Master of Steampunkery First Class with Distinctions. Although this exalted title was self-awarded, I feel the correctness of my actions are obvious, since I have distinguished myself on the lecture circuit, as a skilled orator, sharing with many others an appreciation of the Steampunk Arts. The fact that my lectures were impromptu affairs, held at parks and street corners while atop a soapbox do not take away from their importance, despite what my many detractors might say.

FROM THE DESK OF PROFESSOR CONTRAPTION

So you see I have much to account for my pride at being quite able to enhance this volume, and yet the importance placed upon me to provide for you, dear reader, my knowledge and my expertise throughout this book is what makes me ever-mindful of my duties and fills me with most humble expectation of the task ahead. Thus are my contradictory emotions fully explained.

FROM THE DESK OF PROFESSOR CONTRAPTION

When I discovered this manuscript bound for the printers, I took it upon myself, as an act of selfless generosity to confiscate it, add my profound and valuable thoughts, and slip it back, undetected. I know you, the reader, will appreciate my efforts, for which I ask nothing in return but your everlasting gratitude.

~Professor Maximillion Contraption

What's 'steampunkery' anyway? Well, actually I made that word up, but what about 'steampunk'? That's a real word – honest.

'Steampunk' is a look – a sort of Victorian-era mad scientist-adventurer kind of thing – all clock-work gears and brassy bits (cutting edge technology from the steam age).

Now apply that look to polymer clay and you have some real adventure in store for you! We'll be adding metal gears to our clay projects – making them look like you could wind them up and they'd start ticking! And we'll play with faux leather straps and molded vintage whoop-de-doodles, beaded embellishments, bits of fabric inclusions… all that kind of thing.

FROM THE DESK OF PROFESSOR CONTRAPTION

Well, this is a very abbreviated definition. I feel obligated to expound on the meaning of 'Steampunk' in much more depth. I'll go get my soapbox, if you could kindly meet me at the street corner.

Doesn't that just make you feel like putting on your goggles, cranking the handle of your steam-powered pasta machine and shouting - Excelsior!

Excelsior! Indeed! The very word with which to begin!

HERE ARE SOME THINGS THAT YOU WILL WANT TO HAVE ON HAND

If you're not sure where to find some of these tools, just wander back to the back pages for some **resource information.**

Tools! You're going to need tools to work with polymer clay, but don't worry – you don't have to spend a fortune on them (unless you really want to). Here are the basics:

1. pliers – also for use with the wire (we'll get to that). No special type needed.
2. wire cutters – for cutting wire. Duh. Just any ol' pair will do fine!
3. the "Gotta Have It" tool – another sculpting tool and my other favorite! There are similar tools available in wood and plastic - the wooden ones are fine, the plastic are not as helpful (not because the plastic is bad, just cuz the shape is not so great). But this is the tool you just gotta have.
4. the "Can't Live Without It" tool – a sculpting tool you simply can't live without, this is one of my very favorite tools (check in the back of the book for more info).
5. needle tool – a must-have!
6. cutting blade – makes nice long cuts (and also cuts fingers, so watch it!)
7. needle nose tweezers – very useful when your fingers are too big.

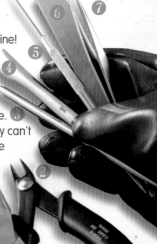

You will also want to gather any other tools you personally like and find helpful! Sculpting is very personal, so anything you want to use – from toothpicks to expensive custom tools – is wonderful to have on hand for these projects.

liquid clay – I recommend 'Translucent Liquid Sculpey'. We'll use it to strengthen certain clay connections.

mica powders – any brand works great as a surface treatment. I like PearlEx brand.

wire, headpins – assorted metals, gauges and styles. We'll use 28 gauge craft wire to secure beads and other embellishments, and thicker gauges for accents and structural supports.

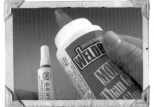

glues – there are lots of glues available. You should have on hand a cyanoacrylate glue (any 'super glue' style -- like G-S Hypo Cement E-6000) and an all-purpose white glue like WeldBond). We'll use glues as little as possible, but sometimes you need 'em!

acrylic paint, brushes, sponges – used to add a patina to the finished baked clay, and also useful for some faux finishes. Liquitex BASICS brand is wonderful with polymer clay!

There are several ways to "age" metals before adding them to your clay projects – look on page 19 for more details!

fibers – any natural fiber, and many synthetic ones, can be baked into your clay projects. If in doubt, stick a little bit in a preheated oven and bake at 275°F (130°C) for 15 minutes. If it doesn't melt, it's good to use!

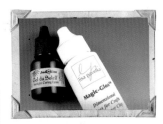

resin/epoxy – this is an optional item, but one you might like to play with. I recommend using a sunlight/UV-light curing resin, but 2-part resins work fine too. I suggest Lisa Pavelka's Magic-Glos, (sunlight/UV types) or EnviroTech Lite (2 part, air-drying type). Small inexpensive drying lights are easy to use – check the back of the book for that!

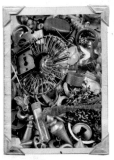

embellishments! oh, we'll need much more space for this category! check out the next pages and you'll see…

mold-makers (2-part silicon) – this is an optional item too, but really super duper funtime! There are several 2-part silicon mold-making options available, but I really love how foolproof these little mini packs are.

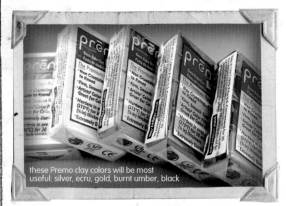

these Premo clay colors will be most useful: silver, ecru, gold, burnt umber, black

Well, this is a no-brainer! We'll definitely be using polymer clay for the projects in this book. There are many wonderful brands of polymer clay available, but I recommend Premo brand – a perfect clay for sculpting. There are more polymer clay tips and tricks in the back of the book as well, so zip back there and give it a look-over before we start.

STEAMPUNKERY CLAY COLORS

The steampunk look is mechanical. Don't worry, that doesn't mean it'll be dull – we'll spice up the projects with colors and shiny things - but the basic clay color mixes should feel like old metals. We'll be mimicking leather and wood colors too, but we'll get into those as they come up in the projects.

Before you mix colors, you'll want to condition your clay (check the back of the book for that info if you are new to polymer clay! I'll wait….) Although, just between you and me, often I don't completely condition each clay color before I start to make a color blend. If one of the clays is softer, more conditioned than other of the clays in the mix, it makes more dramatic effects – better marbling, streaking and stretch pattern. Drama is good.

Mixing the clay to make blends is the same process as conditioning.
Here are some of my favorite clay blends for steampunk projects:

RANDOM OLD METAL:
equal parts of silver and gold, and stop blending while there are still some streaks visible. For a more grey metal, use more silver clay than gold, for a more golden metal, use more gold clay than silver.

OLD TIN:
mostly silver clay with a little burnt umber to deepen it.

ANTIQUE BRASS:
two parts gold to one part black, or equal parts of both for a really deep brass.

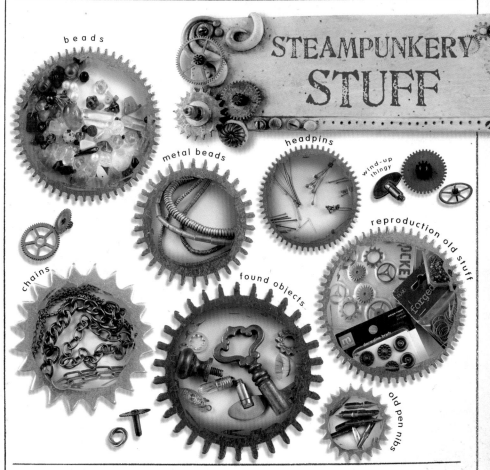

STEAMPUNKERY STUFF

beads · metal beads · headpins · wind-up thingy · reproduction old stuff · chains · found objects · old pen nibs

BEADS beads are always a great way to add flashes of color to the metallic tones of the clay blends. Since these will go in the oven with the clay, don't use anything that would melt (like plastic or resin). Use any beads made from glass, crystal, stone, natural pearls, ceramic or metal!

METAL BEADS don't forget to check your bead store for metal beads – they look great in steampunk projects – especially antiqued brass and copper.

CHAIN you can find chain anywhere! In your junk drawer, at the thrift shop, at bead stores, in a big tangley knot in your jewelry box…. Obviously antiqued metal colors will look the best in steampunk projects.

FOUND OBJECTS traditionally when you refer to "found objects" in art, it usually refers to things literally found, often older, vintage or aged things. For the projects in this book, though – it's perfectly cool if you "find" these things in your craft room, a hardware store or garage sale instead of in a back alley or old barn. So anything and everything that can survive in the oven with your clay - metal rings, automotive parts, architectural embellishments, jewelry bits, enameled things, old keys … release your inner packrat!

HEADPINS all kinds! Assorted metals, sizes and styles.

OLD PEN NIBS these are surprisingly fun to add to clay projects. You can get new ones from art stores and age them (more on aging metal soon), or you can search ebay, thrift stores, old cartoonist's studios….

REPRODUCTION OLD STUFF check out your local craft store, especially in the scrapbooking aisles, for useful items – rivets, brads, reproduction gears – just make sure the items are metal, not plastic!

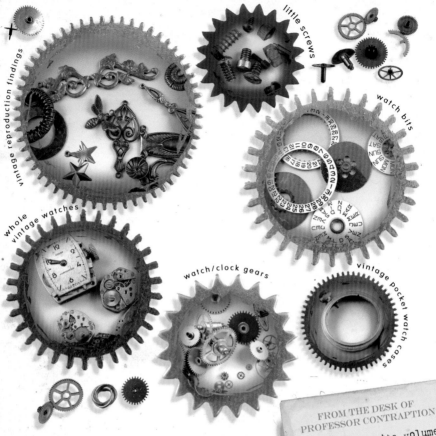

little screws

vintage reproduction findings

watch bits

whole vintage watches

watch/clock gears

vintage pocket watch cases

LITTLE SCREWS
especially old ones! New ones can be aged, though…
keep reading...

VINTAGE REPRODUCTION FINDINGS
there are several great sources for these things and they add a
wonderfully light touch to steampunk pieces. Look in the back of
the book for good places to find these.

WATCH BITS
these are day/month/date rings from old watches – they're really
fun to add. Get them from any place that sells vintage watch
parts.

WHOLE VINTAGE WATCHES
the old ones have all the fun gears! Take 'em apart for all the
yummy innards, or keep them whole for a very compact
"machine" look

WATCH/CLOCK GEARS
from teeny, tiny to large, they're all useful and fun! Get as many of
'em as you can! (Again, check the back for resources).

VINTAGE POCKET WATCH CASES
whole, intact or partial, these are fun to "frame" pieces or for little
steampunk critters to live in.

**FROM THE DESK OF
PROFESSOR CONTRAPTION**

Oh! I could write volumes
about embellishments well,
actually, I don't exactly
know anything specific,
but lack of knowledge has
never stopped me before,
since inventiveness is
the wellspring of
knowledge and ignorance
the prerequisite to
expertise! Or so I tried
to argue before
I was expelled from
Cambridge but let us not
discuss that! I would
propose that the most
important factor
in choosing embellishments
would be their ability to
enhance the look of
extravagance and
antiquity. Yes, that
seems just the thing.

HEART PENDANTS

This is a lead-in to the first project of this book – a hinged heart pendant. But before you do that project, you may want to get yourself in a hearty frame of mind. These are simple steampunk hearts. Some of the fun bits (like leathery straps and overlapping layers) will be covered later in this book in other projects. If you want to make some of these before you get started on the first project, you can download my free "Steampunk Hearts" project online at www.CForiginals.com.

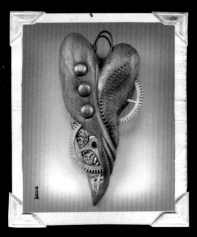

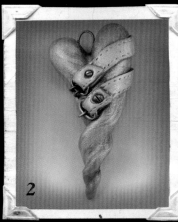

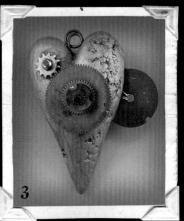

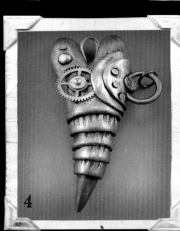

1 Mix burnt umber, gold and copper clay for this color. Mini brads make the 'nails'.

2 Fun straps, huh?! We'll get to those soon!

3 The gear on the side is wired (more about that soon) and pressed into the side of the pendant. The rough texture comes from pressing a bit of rough coral all over the clay.

4 Silver clay, coated with silver mica powder makes this heart look very metallic, huh?!

FROM THE DESK OF PROFESSOR CONTRAPTION

I myself have created the ultimate Steampunk Heart Pendant as a token of my esteem towards a certain Ophelia. Attached is the diagram. Several drops of water (fig.A) enter the tube to be converted to steam (fig.B) by the fully operational miniature steam engine inside the chamber. The steam turns the internal gears causing the door to fling open (fig.C) and a multitude of tiny Cupid's arrows to expel outward with a surprising amount of velocity. I gave this heart pendant to my beloved in hopes of winning her affections. Thus far I have only received a subpoena from her lawyer, but I remain ever hopeful.

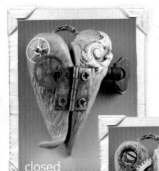

closed

open

I OPEN MY HEART TO YOU

I thought this would be a fun place to start the projects in this book for various reasons that I'm not going to tell you.

Well, that is just rude!

Ok, I'll tell you. *That would have been a very inappropriate beginning, I think.*

Good.

FOR THIS PROJECT YOU WILL NEED:

- polymer clay - gold, ecru, white, silver
- liquid clay
- thick wire about 18 gauge, antique color like old steel thin wire 28 gauge, brass or copper color
- small hinge with screws, aged assorted watch gears, toggle, screw, other assorted embellishments
- two red enameled headpins or two plain, metal headpins two red, round glass beads
- old fob pin or nail or knob
- mica powder - russet colored
- mold of vintage embellishment (optional)
- acrylic paint for patina: white, red, deep brown (burnt sienna)
- special tools: xacto knife, hand-held drill tool, screwdriver

Hearts are interesting shapes. They are a sort of universally appreciated symbol of love and life and other mushy things. It is also a really simple shape to make, so we'll get the book off with a project that is easy. But… then we're going to tweak it! And it won't really be "easy" after all – it will be delightfully challenging. Which is also a good way to start, don't you think? And it incorporates lots of steampunk elements – look at all those gears, you can almost feel the heart operating – but it's softened by the 'carved' curliques. So all in all, a good way to leap right in to the whole world of steampunk possibilities!

Start with a neutral color blend – sort of woodsy color. I used gold, ecru, white and silver clays to make it (blend it so that just a little bit of subtle streaks are left.)

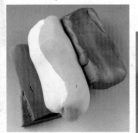

Make enough so that you can roll out a ball about the size of a large hard-boiled egg yolk and still have some left over (we'll be using that soon).

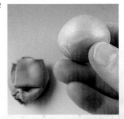

Roll the ball in your palms to make a teardrop (hold your hands so that they make a wedge – that works well).

To make the double mounds of the heart, start by rolling a crease in the round part of the teardrop. This will make it look like a nice, firm bottom – baby got back!

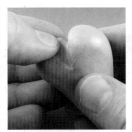

This is one of my favorite tools that I told you about over on the tools page – the "Gotta Have It" tool. It makes creases like this really well!

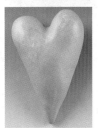

Continue to rock the tool back and forth making the crease deeper. Now use your fingers to lift and separate the two halves. Press to soften any harsh edges to make the halves into the rounded mounds that will make this heart look ever so lovely.

Pinch the pointy tip to make sure it's a nice contrast to the roundy top part. This is your basic heart shape. (Use it anytime you want to make a fun heart pendant – there will be some more about that at the end of this project).

Now, are you ready to be a heartbreaker? Get your cutting blade and slice your heart right in half! (your clay heart, obviously… what kind of book do you think this is?!) Right down the middle. Use a sharp blade, and rock slightly as you press down to minimize distortion.

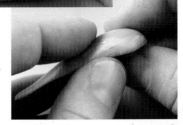

Use your fingers to soften all around the cut edge on both halves.

We'll add a hanging loop now. Just a curve of wire can work fine, but let's make it fancy! I used two weirdo rings I had lying around (if you don't have any weirdo rings, just make one by taking some thick wire – about 18 gauge or so – and wrapping it twice around some wide, round handle to make a double loop). Now use a thinner wire (I used 28 gauge craft wire) to wrap around the top half of the wire loops. You can wrap it nice and neatly or be all wonky with it (guess which one I did?)

Press the ring into the bottom half of the cut heart. The wrapped part should be sticking up where we can see it. Cover the wire on the heart with little balls of clay and smooth them into the heart so that the only wire left in view is the little arch on top. Hold the shape and use your tools to smooth the crease on the top, too.

Turn the heart over so the side you've just been working on is resting on your work surface. Press to flatten all that smoothing you just did to make it more smoothery.

Ok, back to the top of the heart. Slice that in half, right between the two mounds. Smooth those cut edges on both sides with your fingers.

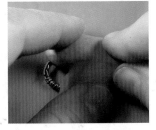

We'll be adding the hinge next. Just a word about the hinge. You can sometimes find small antiqued hinges in craft stores (check that scrapbooking section too), or you can repurpose one from a hinged box. That's what I did. I bought a super cheapo box from a craft store and unscrewed the hinge. Of course it was a hideously dorky gold colored mystery metal one, but a quick bath in the darkening fluid and a scuff or two with the scouring pad and it was good as old! (Ok, maybe a bit more explanation is in order! Sneak ahead in the book to p. 20 for more details!)

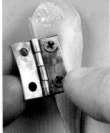

So place the hinge in the middle of the right side of the upper heart you just cut. Make sure if fits, no pieces hanging off the clay.

Screw in the screws. Yup, use a screwdriver and just lightly twist 'em right in. Perfecto! Set that aside for the moment.

I thought the design of this hinged heart needed a little twisty knob thing to look like you should twirl it to start the gears moving (wouldn't that be cool?! But that would be a whole other book to make that work). Anyway, the piece I had was a delightfully naturally aged fob key (or maybe it's some other thingy, but I liked the word "fob" and felt like using it). It needs a channel to make it lay down into the heart half so that there would be less distortion. If you don't have a fob key lying around, any twisty knob thingy would work, or even an old, large nail. Carve the channel with your blade and lay it in. Cover the end with a bit of clay.

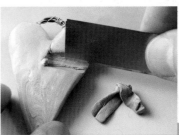

Now we begin adding embellishments to the rest of the bottom half of the clay in order to make it look like the inner workings of a mechanical heart. I'll show you what bits I used, but you can substitute whatever you have on hand – just make it look awesome.

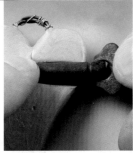

Let's start by pressing in any small round ring in the top half (this is a toggle).

Hmmm, let's give it a bit more depth instead of just pressing in more gears on the surface. Use a tool to carve out a little indentation. Smooth that hole (this is that "Can't Live Without It" tool of mine – you just can't live without it! hee hee).

Let's get a little graphic, but not too gross. Use a small brush to coat the inside of the hole with some mica powder (any of the russet colors work great – a very realistic reddish color, don't you think?)

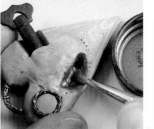

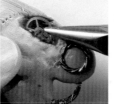

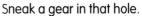
Sneak a gear in that hole.

By the way, these hand written notes are from me, Professor Contraption too also. Don't be alarmed at the variety of my witticism delivery systems.

Ok, time for more gearing – I used a large gear over the top of that hole, but not obscuring it (you can cut the gears to fit with your wire cutters). And a little screw and some red enamel-tipped headpins. If you don't have those (they're a little hard to find – check the resources in the back for info), you can just slip a red, round bead onto a regular headpin. Trim the excess wire from the pin so that you have enough to bend the end into a little hook to leave about a quarter of an inch or less of length. Anytime we use headpins to secure an embellishment to the clay, remember to do that trim and hook trick – that keeps the piece/wire locked into the clay once it's baked (otherwise the wire can pull right out – sadness!)

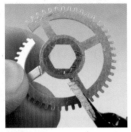 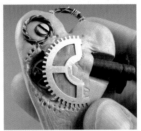 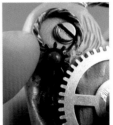

Remember to put embellishments only on the left half – the right half will be covered and you won't see anything over there.

Probably you'll have nicks and goofs all around the surface from trying to stick gears and things here and there. Don't try to smooth them away – make more and call it texture! Isn't that more easier?! And since it's a heart, that texture could

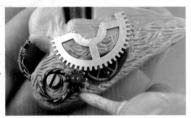

look a bit like heart muscle (or, if that makes you too squeamish, then let's say it's the texture of wood carving – it could be!)

Well, if you're going with the heart muscle thingy,

might as well add a bit more mica powder and make it convincing.

Once you're happy with the gears, go get that top half with the hinge that you set aside and put in on top of the heart - on the right side of course. Press it on tightly (notice that I positioned my large gear so that the ends would be covered by this. Clever, huh?)

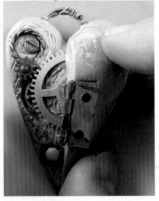

Use tool and fingers to smooth all along the seam, making it look like it all is one piece.

To soften the look, I thought it was groovy fun to add a nice little vintage flourish (it also adds to the "carved wood" look, which is nice). To do this, you'll need a mold of a vintage flourish – or something similar. Check in the back of the book for full how-to info on making a mold. If you don't have some vintage embellishment lying around, look for old jewelry, old furniture and even picture frames for some possible moldable flourishes.

Ok, once you have your mold, roll out a ball of clay (I took some of that extra heart clay mix and added a bit more white to it to lighten it a bit). Press it very firmly into the clay. Use a cutting blade to slice away the excess by moving the blade straight across the surface. (A dull blade works best so you don't slice into the mold too easily). Press, pull or ease out the impression.

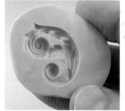 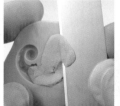

Press in gently onto the surface of the heart wherever you think it looks best.

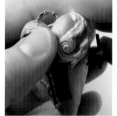 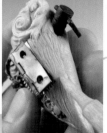

To emphasize the wooden, carved texture, scratch the surface of the heart all around. Ok, we're on the home stretch!! Of course, it's also the hardest part. Better go get a snack to boost your energy. If you're getting something chocolatey, would you bring me back some?

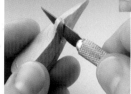

We're going to hollow out that left half of the top of the heart so that it can fit over the embellishments. Use an xacto knife (or other pointy sharp blade) and carve out the excess clay so that only a shell remains. Be careful – you don't want to distort the shape. Work slowly, keep your hands clean (use baby wipes) and cool (an ice pack or hold an iced drink).

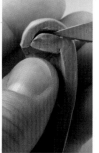

Once you've carved out what you can, use a tool to smooth the raggedy edges so they are more smooth. It doesn't have to be perfect. Now use your fingers to finish smoothing and to re-perfect the shape.

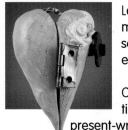

Lay it into position to check shape. Tweak it if needed to make it look good. Remember this is supposed to look old, so the joints don't have to line up perfectly. Gaps and irregular edges are fine, as long as it looks interesting.

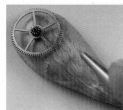

Ok, take it off, wad up a little bit of tissue (the nose-blowing kind, not the present-wrapping kind) and place it under the clay piece to support it so that you can add gears and texture without the shell collapsing.

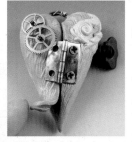

Lay it back on top (take the tissue out, but save it) and see how everything looks. Adjust to suit your tastes. For example, I bent up the tip of my heart, for no real reason… just 'cuz.

We're not going to screw on the other side of the hinge at this stage, it's too easy for the unbaked clay to squish. So, let's add a bit of texture and powder to the inside and then bake both parts to assemble afterwards.

Baking is the easiest but most important part of polymer clay creativity! There is more about baking in the back of the book, so check back there first if you want to. Preheat your oven to 275°F (130°C), place the top bit of the heart back on its tissue paper pillow, and bake both parts of the heart on a piece of cardstock paper (like index cards or similar) for 45 minutes. (This is for Premo clay. If you are using a different brand of clay, follow the manufacturer's suggestions). Let the pieces cool completely before moving on to the next part.

Ok, your pieces are cooled, it's time to add the patina and then assemble it! Wheeee!

Assemble your supplies for this part - paint, brush, a pile of ratty sponges, (wettened, then wrung out really dry), a bowl of water.

Use acrylic paint to accentuate the detail work and increase the appearance of age. I used a deep reddish brown paint (burnt sienna). Don't use extra water, and work a small area at a time – acrylic paint dries quickly. Begin by brushing the paint deep into the details. Then use sponges to wipe off the surface paint leaving it only in the texture lines and deeper details. Use lots of sponges – wipe, toss into the water, get a new sponge and wipe more, toss into the water…. Oh, by the way, you can pull out the loose gears to make adding the patina easier – we'll put them back on later with glue.

Next you can use paint to add more color. A little bit of deep red on the inside, if you need it, will add to the "authentic" look of the heart's innards! And finally, a bit of white paint brushed over the molded embellishment on the front will give that a bit more notice. You don't have to do this, but it looks good. The trick is to use a brush with squared-off bristles, and to make sure the white paint is slightly tacky before brushing it on (squeeze a small bit of paint onto a piece of paper and brush the paint back and forth with the brush to dry it slightly before using it). Just lightly brush the top of the clay embellishment. Sweet! Let all the paint dry.

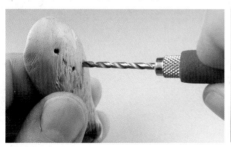

So now the only thing left to do is screw in the other side of the hinge and we're done!

Place the front half in position, flip over the hinge and use a pencil to mark the holes. Pull out the gears if you want to make it easier.

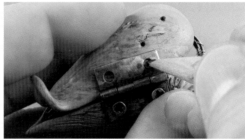

Let's drill some starter holes to make screwing in the screws easier. If you have a little hand-held drill tool, use it, if you have an electric drill, that works too, but you have to be more careful. It's best if the drill bit is thinner than the screw. So screw a short hole into the clay on the marked dots. Use a lil' screwdriver and screw them in slowly – don't push too hard or you may crack the clay. Don't worry if the screws pierce through to the inside, just put a dot of glue (any type will work) to help them stay steady.

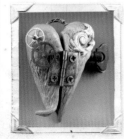 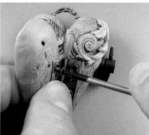

While you've got the glue out, add a drop to the ends of the gears that we took off the front, and press them back in the holes. A superglue or jeweler's glue will work best for this.

That's it!

Really? There's nothing else in the entire book? Could you repeat the part about the screws? I got confused.

If you find that your heart flops open, get a white candle and rub it on the hinged piece and the base piece where they touch to help them 'grab'.

GALLERY

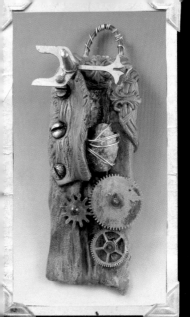

This pendant uses elements from the hinged heart project – the hanging loop is done the same way, and molded vintage embellishments are added. The idea of a hinged opening (although not moveable as in the hinged heart project) is here as well. The fun old patina is something added to the finished piece – doesn't that look swell? Info about that is coming right up on the next pages! Yippee! Oh and isn't that sling-shot-looking thingy cool? It's some clock piece, I don't know what... but I like it!

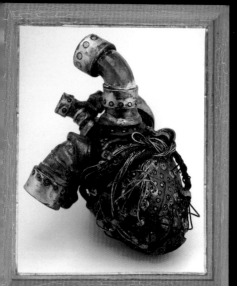

GUEST ARTIST: William Wallace

This is the heart the Tin Man was looking for. Who knew it was here in this book c along? This heart is all polymer clay – including the wiring. Patinas and antiquing were added afterwards to create this dramatic piece.

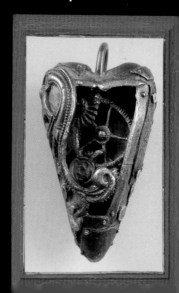

GUEST ARTIST: Christi Anderson

Ok, so this isn't polymer clay, it's silver clay – but it efinitely is steampunk! Being able to see inside to the inner workings of this heart creates a wonderful dimensionality to this amazing piece.

This is a really important topic! The Steampunk look is dependent on a feeling of antiquity. Sometimes the embellishments you add to the clay are already old with a natural patina of rust or verdigris or just grungy-looking some other way. But what about nifty metal things you find and would love to use, except they're new, or made out of that cheesey, bright golden metal or dull silvery stuff? Not to worry! There are all kinds of things you can do to make blah metal look deliciously old!

Check the Resources section in the back of the book on places to find these products.

ALCHOHOL INKS

FROM THE DESK OF PROFESSOR CONTRAPTION
Well, personally, I think the best method for aging any metal bits is to use a time machine to travel back a hundred years or so, deposit the metals in an area where they would naturally age, but not be tampered with by the succession of humans through the decades, then uncover them in the present. I am working on both a time machine, and a secluded area to serve as a depository. As it happens, I am looking for investors, so if you are a visionary like me and additionally have a small, disposable fortune, I think it advisable that we discuss this, over tea perhaps?

One of the easiest ways to age metal is to use alcohol inks directly on the metal. The color sticks permanently on all non-porous surfaces. Ain't that great! I like to place a drop of each of several "old" colors – browns and rusts and greens – and use a paintbrush to dabble 'em over the surface of the metal. Let it dry and then use the 'aged' metal bits in the clay. Easy!

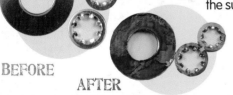
BEFORE
AFTER

HEAT

This one is fun, if you like fire. If fire worries you, use one of the other methods instead. An open flame applied directly to most metals will age them most amazingly! The smartest thing to use is a mini torch (many art supply places carry them, and many bead shops too – for resource info on all the materials used in the section, check the back of the book!) This uses butane to produce a flame and is very controllable. Lay the metal piece down on a fire-proof material, like a fire brick (you can get those at the same place you get a torch, usually), or just work outside on a brick. Pretend you're the Torch and Flame On! Keep the flame on the metal, but stop often to check on the progress. (Just between you and me, before I got my torch, I held the metal with pliers and stuck it in the flame from my gas stove and that worked well. I'm not saying that you should do that, of course, just that I did... it's not my fault if you want to get all pyro in your kitchen. Pssst, cool the hot metal with a plunge into cool water – the metal, not yourself).

There are several fluids that help age metals. All of them require a bit more safety – ventilation, gloves, that sort of thing, since often they are acids or have noticeable fumes, but common sense should tell you that handling chemicals always calls for caution. (If you don't have any common sense, you can acquire some by sending $100 in pennies and a self-addressed, stamped envelope to: Common Sense, PO Box 000, Gullibility, NJ. 12347).

LIVER OF SULPHUR – this comes in little chunks that are added to warm water to create an icky-smelling, pee-colored liquid. Metal to be patina-ed is cleaned first and soaked in the fluid (although usually, repeated dipping and rinsing yields a better result than soaking). Good for most metals, especially silver and bronze.

BEFORE
AFTER

BLACKENING FLUID – you can tell by the skull on the bottle, that you should be careful with this stuff. But it ages all metals awesomely! Since this fluid really does blacken metals, you'll want to follow these steps for maximum fabulousness – otherwise you'll just have a blackish mess:

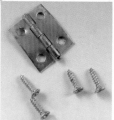

1. Apply the fluid to the metal with a brush (use a nonporous container to hold the pieces. Avoid touching them with your finger. Rinse the brush and wash your hands immediately after coating the metal). This will immediately blacken the metal in an irregular pattern.

BEFORE
AFTER

2. Rinse the metal and set to dry on paper towels. You can pat dry if you're impatient (like me).

3. Use a piece of fine steel wool (00 or 000) or even the scubby side of a sponge (I use this – it works great) to polish the metal. This will remove the black from the high areas, allowing the under metal to show, and it also makes fine scratches (which adds to the allusion of age).

4. Tah dah! Old!

(There are other similar, less caustic products available, see Resources, in the back of the book)

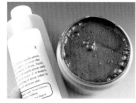

METAL COATINGS – Ok, this one is really fun! There are several products that are a metal coating/patina system. The metal is a liquid in which microscopic metal particles are suspended – you paint this on the surface to be aged, then add the patina portion of the product to create the look of old metal. This is a product for making non-metal things look like aged metal – so of course that means that this is a product for making polymer clay look like old metal! Ain't that swell?!

Just follow the instructions – first the metal coating is applied, then the patina fluid is applied with a sponge on the still-damp metal coating. The patina intensifies as it dries – so wait overnight to see how you like it.

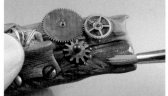
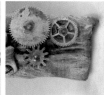

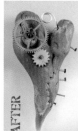

BEFORE AFTER

You can usually find iron/rust and bronze/verdigris- both are groovy fun!

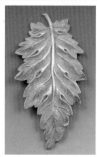

A nice little side-benefit is that you can use just the patina fluid on metal pieces to age them.

COLORED PENCILS – this is a neat little trick for quickly adding a verdigris patina to metal findings that are already an antique color (like reproduction vintage findings). Use soft-leaded colored pencils in verdigris colors – bright green, deep green and some brown for toning down the color a little. Rub the pencils hard into all the cracks and crevises. Use a scrubby sponge or fine steel wool to take the pencil off the highest surfaces. It's best to use a spray fixative afterwards to set the pencil more permanently.

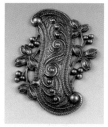
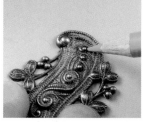

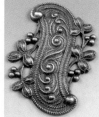

So, there you have it! Some interesting ways to add that look of authenticity to your steampunkish embellishments. You should age the metal bits before you add them to your clay, it's easier that way.

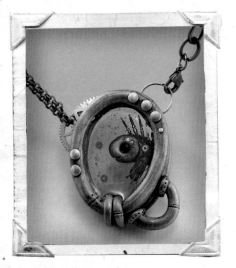

UNDER THE SEA-THRU PENDANT

FOR THIS PROJECT YOU WILL NEED:

. polymer clay: silver, gold, black, green pearl
. liquid clay
. natural sheet mica about 3x2"
. eye bead one dark, round bead, 4-6mm
. teeny, tiny screws about 6 or 7 (substitute: headpins)
. spikeyscrew things about 4 or 5 of them for fins (substitute: headpins)
. headpins 3
. teeny, tiny gears one small (5-10mm), and 5-8 others, even smaller
. larger gears (15-20mm) and or wire rings at least 3
. mini brads 5 (substitute: headpins)
. (optional) mica powders: blue, antique gold, antique silver, antique copper, spring green
. acrylic paint for patina: blue, dark brown (burnt umber) and brush, sponges to apply
. seed beads 5-8, assorted sizes, pale blue
. resin (preferable UV-hardening resin, but 2-part air-drying resin will work too
. (optional) UV lamp to harden resin
. extra tool: scissors

This next project is another wearable, but if you're not into necklaces, it would also make a nice little mini wall piece – can't you just see it dangling from the nook in your Nautilus bathroom? (the submarine from "20,000 Leagues Under the Sea"… well, I thought it was a clever reference anyway).

It is a clever reference! Jules Verne is a total dreampunk.

As usual, start with conditioning your clays and mixing a color. For this project, we're going for an 'old marine porthole' kind of color – so that "random old metal" mix (from the front of the book, remember?), only let's modify it a bit – more silver than gold and a bit of black to deepen the blend. Leave a few subtle streaks in when you mix it, if you can.

Ok, now take some of that clay mix and roll out a snake – about the thickness of a pencil.

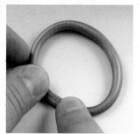

Loop the snake around into an oval. Slice the ends and smooth them together to make the oval seamless. Ooh, well done! (I know that was actually easy, so of course you did well). Press the clay all around with your fingers, to flatten it slightly.

Now we're going to cut a piece of natural sheet mica in an oval to match the clay one – you can trace your clay oval onto a sheet of paper, cut it out and use that as a pattern if you want to. Use a pair of regular scissors to cut it (the mica, well, and the paper too, I guess). Of course the mica oval needs to be little smaller than the clay, so it can lay on top of the clay without sticking out past the edges.

Roll out another snake of clay and lay it on top of the first oval/mica. Press it down all around, sealing the mica in between the two layers of clay. Make sure the clays touch each other since that's where the seal occurs (if your mica oval is the right size, this will happen automatically).

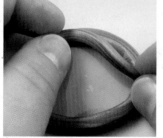

Ok, now it's time to make that fun little steampunkish fish that we see through the porthole (which is the whole point of this piece, actually). Let's start with a fish color clay (half and half mix of green pearl and gold clay will do it). You don't need much at all. Now roll some of the clay into a little ball (about the size of a pea), and shape it into a jellybean (roll the ball into an oval and bend it over your finger – tah dah! jelly bean!)

With your fingers, flatten the shape to about half its thickness, and continue to flatten just one end (this is the end that will be at the edge of the porthole – the not-the-head end).

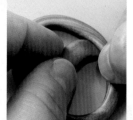

Lift up the edge of the top oval of clay and slip the flat edge of the fish under it. Perfecto.

I beleive the correct latin translation is "Perfectus"

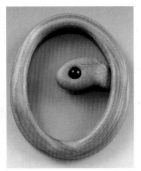

Add an eye bead by just pressing a dark, round bead into the center of the clay. Normally, we'd wire it up first to make sure it would stay securely in the clay, but the cool thing with this project is that the fish is going to be completely covered with resin 'water' so, no need to secure any of the embellishments, just press them in firmly!

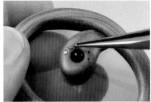

How about a few tiny little screws all around the eye? That'll look cool. Just press them in (I found that poking in some guide holes with the tip of a needle tool first was helpful).

I had some weird spikey-screw things (some watch part or other – probably the spikey-screw part) which I thought would make the fins up at the top of the fish. Whatever spikey embellishment you have around will work well. Experiment! Press the spikey-screw things (or whatever) right into the clay at the top of the fish and angle them forward.

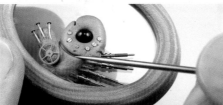

For the bottom fin (you know the one that looks like his arm), just roll out a little teardrop of clay and flatten it. To echo the look of the spikey bits in the top fin, I used some headpins (chopped short) pressed into the clay.

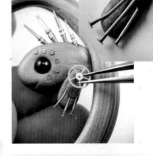

Cover the tips of the pins with a little teeny, tiny ball of clay on top. Press the fin onto the fish's body. Oh, and press in a gear too. You know you want to add a gear right about now. Good.

With a needle tool, press in a curved line - between the head from the body – you know, the gill thing.

And now of course, the fun part - add any other embellish-ments to the body that you think look good. I had teeny, tiny gearish things that looked great as a body pattern, so that's what I used.

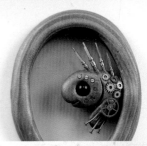

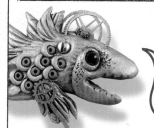

Oh, I say! I thought I was supposed to be the fish in the porthole... drats! That's what I get for trying to save a little money by walking to the audition, instead of taking a nice, swift lorry!

Neener Neener!

Ok, the fish is done, it's time to make the porthole more impressive. We'll need to add some steampunky gears and loops, which can double as hangers for the finished piece if we're clever (which of course we are). So, press in some wire rings or partial gears into the top clay – offset is better than perfectly symmetrical.

Roll out one more of those snakes of clay to make one more oval (so we can sandwich the embellishments into the clay layers and give the porthole more depth). Start by using your cutting blade to slice one end of the snake straight and press that part onto the base, then position the clay around on top of the oval, pressing in place as you go. As you reach the end, slice the snake again and press down so that the two ends touch each other – no blending this time, just leave the ends touching.

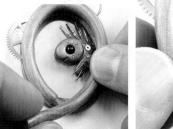

Ok, now for a little submarine-style clay "pipe". Roll out yet another snake of clay (a little thinner this time). Bend it in an arch and use your blade to slice it straight across.

Roll out two little balls of clay in a contrasting color (something brassy – gold+black combo maybe?) Flatten them with your finger and if you have a tool with a flat end (like this needle tool), you can press a little indentation in it too.

Dab a drop of liquid clay on both ends of the arch and press those ends into the little indentations on the flattened balls. Push the clay ends firmly around the 'pipe' ends to connect.

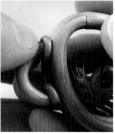

Add another drop of liquid clay onto these new ends, then push the arch firmly onto the edge of the porthole (near the bottom). Be really firm (but no smooshing).

I'm fairly certain that nautical-type port holes have rivets and such on them, so assuming that's true, let's add some! Use mini brads if you have 'em (headpins if you don't). Press them in where you think they'll look nautical-ish. Don't forget to bend one of the prongs over into a hook to hold it into the clay securely.

And of course, keep the rivet look going by adding rows of little dots along the edges of where the pipe ends meet. Ooh, and how about a row of the dots around that brassy clay at the connection of the arch too?

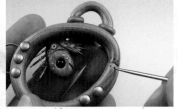

Hmmm, I have another snake of clay left, what to do with it? What to do? How about wrapping it around the oval - from the inside (right up next to the mica) around to the backside? Add another one! Perfect.

And it's done! Well, ok, a little powder – on the fish (maybe some blue?) and some to add interest to the porthole too (antique gold, copper and silver and misty green for that hint of verdigris). Don't overdo it!

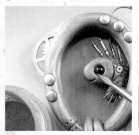

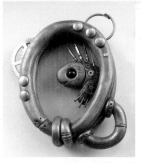

Bake it! You know the drill – 45 minutes, preheated oven, 275°F (130°C), then let it cool completely.

The last bit is to add a patina with acrylic paint (again, you know the drill – check in the back of the book for a refresher if you need it). I suggest using deep blue and dark brown paints.

Oh, I thought you said dark brown PANTS.

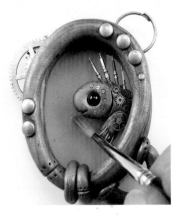

Once you're done with the patina, and since you have the blue paint out already, rinse your brush and use the water in the bristles to turn a little of that blue paint into a very light wash. Swish it on the surface of the mica – very, very lightly! This will give the mica just a hint of pale blue coloring (which will take away that snotty color that the mica often has).

Once all the paint is dry, it's time to add the resin, to make that underwater look happen! This really is the fun part. There are two kinds of resins to use, a two-part, air-drying resin and a UV-curing resin. (Resources in the back of the book will show you where to look for these products.)

If you use the air-drying resin, mix up the parts according to the instructions and you'll fill the front of the porthole in one step. If you use the UV-curing resin (which is less messy), it will take three or four layers of resin to build up the depth. I used Magic-Glos, a great UV-curing resin, and a UV lamp (the kind used in nail salons which are inexpensive and easy to use). Curing time in the lamp is about 15 minutes per layer. You can also cure UV resin in sunlight – just pick a nice, non-windy place so no dust blows into the resin as it cures.

For either type of resin, just squeeze/pour in the resin and rock the porthole slowly around in a circle to help spread the resin to all edges of the clay.

The resin will naturally trap air bubbles, and normally we'd get rid of these (there are several methods), but for this project, we'll leave them in since they add to the watery look and help the resin from being so see-through that it would be invisible! (Ok, so that's a bit of an exaggeration, but you know what I mean.)

Let's make the 'water' a bit more bubbly-looking by adding some pale blue seed beads to the resin. For the UV-curing resin you can place the beads on top of a layer of cured resin, and then gently pour in the next layer over them. For the air-drying resin, use needle nose tweezers to insert them into the resin (quickly – the resin starts curing right away). You can use a needle to pop the air bubbles that often get trapped inside the beads, if you want to.

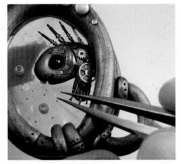

Once the resin fills the porthole enough to cover the fish completely, and it's all cured/dried, it's a good idea to flip over the pendant and add a shallow layer of resin to the backside. Leaving the mica uncovered isn't a good idea since it's more prone to scratching than the resin.

The only thing left is to string it up! (pssst, use chain – it looks cool, huh?)

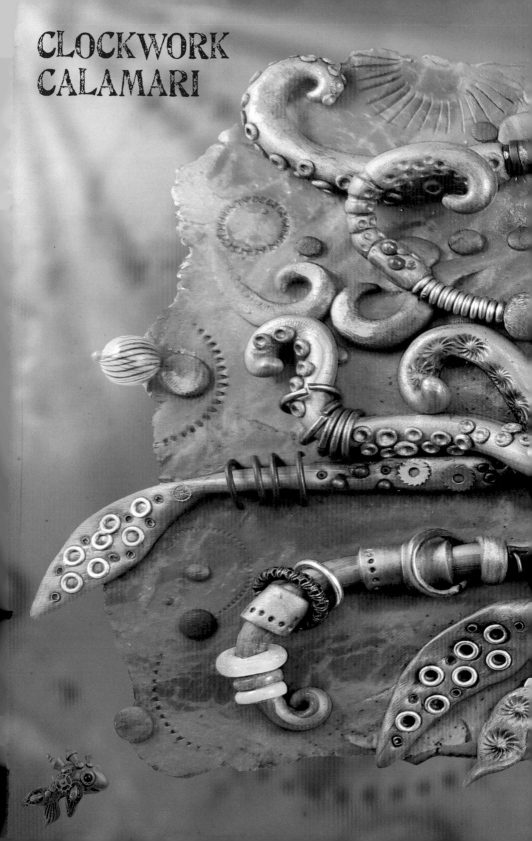

CLOCKWORK CALAMARI

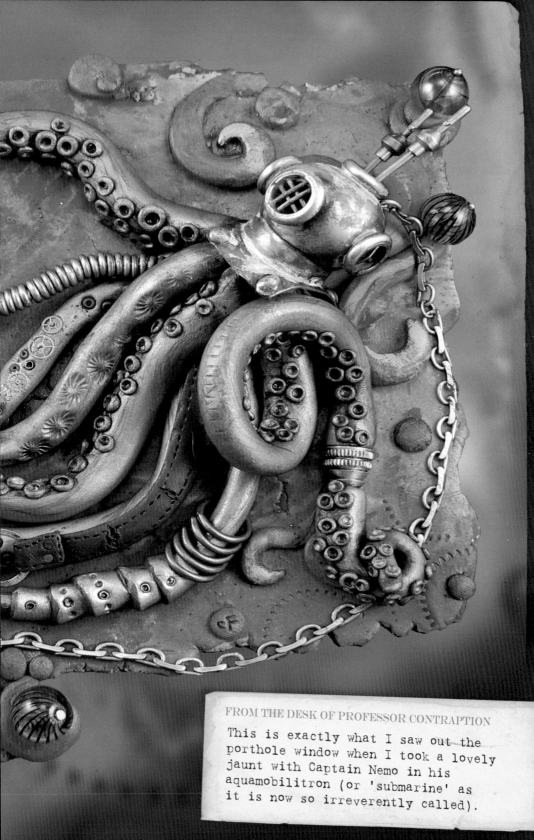

FROM THE DESK OF PROFESSOR CONTRAPTION

This is exactly what I saw out the
porthole window when I took a lovely
jaunt with Captain Nemo in his
aquamobilitron (or 'submarine' as
it is now so irreverently called).

20,000 LEAGUES GALLERY

This dude really looks like the mechanization works, huh?! It seems like those spokey wheels and gears would be chug-chug-chugging along as he swims, making a nifty little bubbly, humming sound that underwater ships and subs make. If you want a complete step-by-step on how to make this guy, he's a downloadable project available on my website: www.CForiginals.com.

When you're a time-traveler, like this fellow, you tend to pick up a lot of refittings and energy boosts and well, you know, time-traveling hardware. Like the chromo-denominator (that number dial) and the quantum riffler (looks like a fancy fan-blade) and the boomerang-atron (upper flipper, brass thingy). Very important stuff.

See that cool engraved silvery piece along the front seahorse's fin? That's from an old pocket watch – here's what I want to know: why were those pieces so gorgeously engraved? They were hidden INSIDE the closed watch where nobody but the watch maker would see them?! I'm pretty jazzed that now they can be used as an accent piece that can finally show them off!

The strength of this design lies in several interesting found objects incorporated into the claywork. A panel from an old brass pocket watch, a reproduction vintage finding and some weird four-armed thingymagig. Making the fish from a brassy-colored clay makes those pieces fit right in! The contrast of the cool silvery-color of the screws keeps the piece from being too monochromatic.

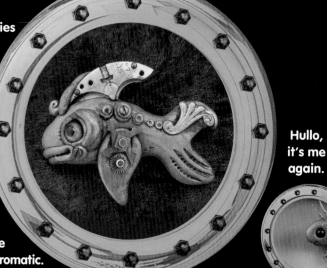

Hullo, it's me again.

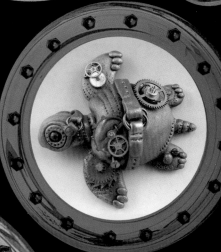

What's going on on this page huh?

Never under estimate the power of a good leather strap to hold it all together.

The steampunk elements don't always have to be overwhelming – some times they can be subtle, like in this brooch. The mix of old brass, gears and screws contrasts well with the crisp, clean blues and whites, and doesn't it feel futuristically archaic? That's steampunk, baby!

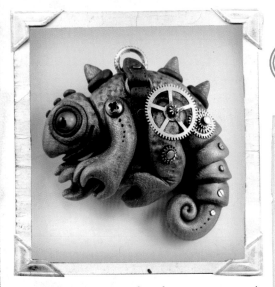

FOR THIS PROJECT YOU WILL NEED:

. polymer clay: silver, gold, green pearl, black, burnt umber
. eye: either one lampwork glass eye, or a round, dark bead, about 6mm
. wire: 28 gauge, a few inches
. a small metal ring to use for a hanger (substitute metal wire loop or watch gear, 15mm or larger)
. jump ring (or small circle of wire) one
. headpins 5 or 6
. little screws 5 or 6, assorted sizes
. assorted gears, varied sizes
. mica powder gold and or antique metal colors
. acrylic paint dark brown, green or blue

This chameleon is one of my favorite steampunk things to make - big googley eye and curly tail and grabby little hands – doesn't that sound like fun?

Start with clay, of course. If you have leftover "old metal" color from the porthole project and some of the green mix from the fish, blend that together and you'll have a perfect lizard mix! (If not, just blend lots of silver with a little gold, and green pearl – you can add a touch of black and/or

burnt umber to darken the color if you wanna).

Pull enough clay from the blend to roll out a ball of clay about the size of a small hard-boiled egg yolk (and have at least half as much left over – we'll need that for legs and arms and stuff).

Roll the ball into a long, narrow teardrop. Use your palms held in a wedge shape for best results.)

Chameleons are a very old species, they've existed for literally thousands of years. Back when thunder lizards roamed the earth, they used to be as tall as houses, only less square shaped.

Shape the fat end by using your fingers to turn and press to make that end taper to a blunt point. It should look like some cosmic tadpole at this stage (that would be a good name for a kid's book, huh? The Adventures of the Cosmic Tadpole).

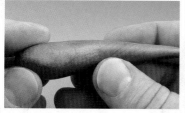
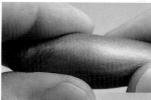

My nanny used to read it to me every Thursday

In order to make the classic chameleon shape, we'll use a tool (look, it's that 'Gotta Have It' tool again! Man! Is that thing useful!)
Use a tool (you know which one) and use it to press in a line from one side to the other, about half an inch or so from the tapered end. If you hold your tool at an angle, you can press in the neck line as well as push down the clay right behind the line – this will make a sort of slope-backed look, which just happens to be the classic chameleon shape (how convenient).

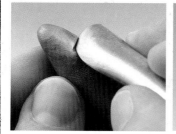
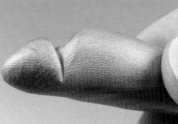

If your line/wedge gets a little wide, just push face and body towards each other to make that lizard hunch.

You can make the body long and crawling, or curled up – I'm going with curled up cuz it works well as a pendant that way, but you do whatever you want, I'm ok with it.

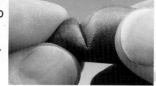

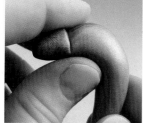

If you're curling, use your thumb under the belly to bend the body into a curve – nice and roundy.

We're going to add some armor-plating to the tail, so first we have to thin and shape the tail in preparation.

Gently pull, pinch and twist to elongate and thin the clay. Pinch off the excess as the tail gets ridiculously long. Once the tail is just a little thinner than you think it should be, and no longer than the length of the lizard from nose to rump, you're done.

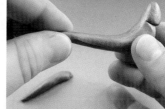

Curl the tip of the tail up like a tight snail's shell. It's a chameleon thing).

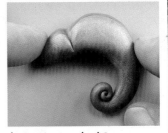

Lay him on your work surface and shape him – curled tail tip, rounded back, head tilted down slightly.

So now it's time for that armor-plating. Ok, well, I suppose we should call it something a bit more steampunky than "armor-plating". So, let's call it brass plating instead, ok?

Indeed! 'Brass plating' is definitely preferable to that other nomenclature. Bravo!

So obviously now we need a brassy colored clay (you know how to mix that!) and roll it through the pasta machine set to a few notches thinner than the widest setting (if you don't have a pasta machine, this is about the thickness of a dime).

Use your cutting blade to cut some strips – about 5 or 300… depends on how long your tail is. They should be about a quarter inch thick, or about 10-12 mm, whichever.

Wrap a strip around the tail as close to the end curl as possible. Bring the ends of the strip together in the back (the part that lays against the work surface, duh). Pinch them together tightly. Tighter than that – don't be a weenie. Yeah, like that!

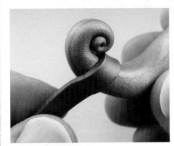

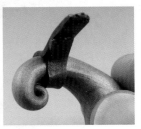

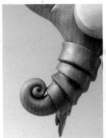

Wrap the next strip overlapping the first. Repeat the pinchy thing. Keep going – four or five total strips (or more if needed) until the plating goes all the way up to where the body bends (his hip area, in case you were wondering).

I wasn't.

Now, hold your chameleon in your hands with the messy, pinched-strips side showing. Use your cutting blade to slice off that unsightly mess, even with the surface of the tail. If you don't get it close enough on the first cut, slice again. Remember to aim the blade directly at your wrist artery for extra drama (Ha! Kidding! Just my silly way to remind you to be careful with that sharp blade).

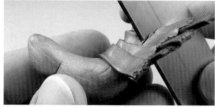

If you've cut it deeply enough (the clay, not your wrist), you will have a bit of a gap in the strips. Just pinch them together gently. Then turn the chameleon over and press

down from the top and rock back and forth a little to smooth those back pinches. Doing it this way reduces the chance of smooshing the front.

To minimize the appearance of him wearing a metallic diaper, let's blend that clay into the body so it'll look more like he just grew brass plating. Much more realistic, huh? Use a tool to smooth the top of the strip clay onto the body clay. Use your fingertips to smooth away all the tool marks.

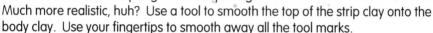

Let's make his cute lil' face now. Use your finger to press a little indentation in the center of the head in preparation for adding the eye.

Grab some of that brassy clay mix and roll a very small ball of clay. Press that right in the center of the face (well, slightly towards the top of the head), where you pressed the indentation (now he's a pancake face).

With another color clay, roll out a smaller ball, press it on top of the other one (now he's a double pancake face). Use a tool to impress a hole in the center of both layers.

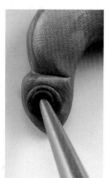

If you have a nifty glass eyeball like this one, use that! (check the back of the book on where to find this cool item!) If you don't have a glass eye, use a round dark bead (like the one for the fish in the porthole project.

For the glass eye, just press the stem into the center of the pancakes (if we could we'd bend the stem into a hook, but this kind of wire is much too stiff).

If you don't have a glass eye, that's ok, we can use a round, dark bead. Instead of just pressing it in, though, let's add a wire tail to help it stay in more securely. You can use this method of attaching a wire tail anytime you're going to add a bead accent to your clay projects. First, snip off an inch or two of 28 gauge wire and slide on the bead. Pull the ends of the wire together so that the bead rests in the bottom of the "U" you created. Press the wires together and use pliers to grab them about half an inch from the bead. Twirl the bead with your fingers to make the wire twist firmly up to the bead. Trim off the excess wire to leave about a quarter inch of wire. Bend the end of the wire over into a little hook (which of course is what keeps that bead secure). Press the eye bead into the center of the pancakes and press it in nice and deeply.

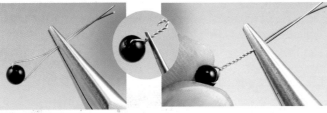

It has personality already, huh? So let's add lots more personality by giving ol' lizard boy a mouth! Start by pressing in a small indentation to get the mouth started – just a straight line will do it.

Lucky for us, chameleons have nice wide grins (well, most of 'em), so use a needle tool to continue the line towards the eye. Curve the line up for happy lizard!

Want to know a fun little trick for making the lizards smile very toothy? He'll look even more lizard-ish. Use the tip of a needle tool and press little dots along the length of the mouth line – instant teeth!)

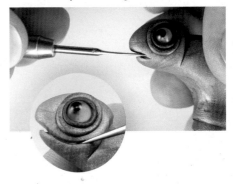

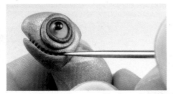

So now let's move on to adding a way to hang the lizard when he's done. You can use an arch of wire, just like the hinged heart project, or a partial gear like in the porthole project. I had a small round watch bit that I thought would work well as a hanging loop, so I added a little wire tail for extra strength, and pressed it into his back. You use whichever of those options you want to!

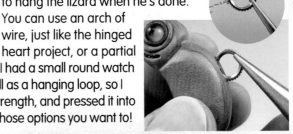

Usually pressing the hanging loop/ring/gear into place leaves some messy marks, so instead of trying to fix them by smoothing the clay, let's lay a faux leather strap right over the area. The leather straps are really fun to make! You've seen some uses of these faux leather straps in the photos of some of the other steampunkery things in the gallery pages so far. Haven't you been itching to make some and use 'em?! I know, huh!

Start with a leathery colored clay – I used burnt umber because it contrasts nicely with the chameleon color – and roll out a small snake of the clay – about 2 inches long or so. Flatten the clay with your fingertip (finger prints make a good leathery pattern on the clay).

Cut the strip in half and make both halves smooth and rounded. Pick up one of the halves and slip it through a jump ring. (Obviously an antique-color ring will look best. You can make a ring by wrapping wire around a tool handle).

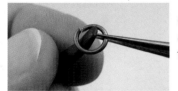

Once the tip of the clay is through the ring, press it down onto the clay strap and press to attach. Pull the ring forward to keep the ring as open as possible.

Now slip the other half of the strap through the ring too, press it over to attach, and pull it in the same way.

Slip the leather strap through the ring on his back, center the strap so that the loop and flaps are nicely visible and press the clay strap in place. See, that covers up the messy bits from the ring insert. Sweet.

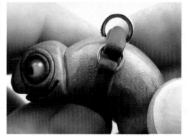

The leather strap looks good, but let's make it look fabulous! Start with a couple of headpins, use pliers to bend an angle in them, close to the head, then use wire cutters to trim off the excess pin, leaving only about a quarter inch or less. The bend is to help them stay in the clay (since bending a hook into the wire would make it too wide to go through the strap without making it too distorted – this bend will work pretty well instead.

What a coincidence, I have shoes made of leather!
And they have straps, and buckles!

Press one of the bent pins into the clay flap on each side of the ring. It helps to use needlenose tweezers. Press the pin in, according to the bend and adjust the angle as you press it in.

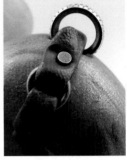

And now to add little stitches! Use the tip of a tool or the point of a needle tool to press a row of little dashes/dots along both sides of the faux strap.

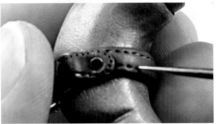

Doesn't that look great! Yes it does!

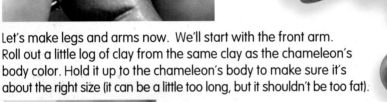

Let's make legs and arms now. We'll start with the front arm. Roll out a little log of clay from the same clay as the chameleon's body color. Hold it up to the chameleon's body to make sure it's about the right size (it can be a little too long, but it shouldn't be too fat).

Hold the log and press one end to make it a bit more squashy, so that it looks a bit like a golf tee.

Chameleons have weird toes – two in the front, two in the back. So, pull each end of that golf tee-ish top to elongate them a bit.

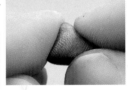

Use a little blade to slit each of the two sides in half. Use a needle tool to smooth the clay in each slice. Now use your fingers to elongate each of the toes a little longer. Take your time, this step can be a little hard – it's no problem if the toes get too long – just snip 'em shorter. Fat toes look dorky, so make sure they are thin enough. Make sure they still aim two front, two back.

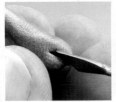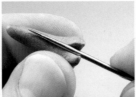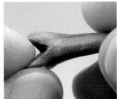

Curl the toes towards each other.

To add the arm, first use a tool to make an indentation where the arm will go – the shoulder area.

Next make sure the arm is not too long (pinch or slice off any excess), and give the arm a bend about halfway – lizard elbow. Press the arm into place. If you have a little screw, press it into the top of the arm – looks neat huh?

SCREWY TRICK!

If you don't have a good screw to use in your project, you can make one from clay! Use a tool to press a hole into the area that needs a screw. Then roll out a tiny, little teardrop. Press the teardrop into the hole, pointy-side in. Push down on the clay gently – it should spread out a little, looking like the head of a screw. Use a tool to press in a line – tah dah! Looks screwy, huh?! Add a touch of mica powder to make it a bit more metallic.

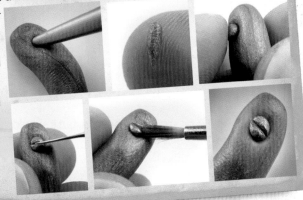

The back leg is almost identical to the front one. It's a little bit bigger – just a little bit, not much. And it's got different bends to it. So, first make another limb just like the arm, only, you know, a little bit bigger. Now use a tool to crease the clay right above the toes and bend the foot into that crease (that's sorta' the ankle bend) so that the foot is almost at a right angle to the leg.

Then you can bend the knee (it will go in the opposite direction to the elbow bend in the arm). The leg will look a bit like an "S" now.

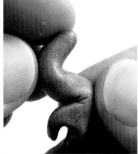

My own ankle once bent like this – I did not enjoy the experience.

Adjust the length of the leg, just like you did for the arm, and press in onto the lizard (you can make another indentation first with a tool too). The leg can be positioned so that it's a bit behind the arm if that looks better (and it usually does).

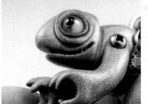

If you really liked making those grabby little hands, or if you think your chameleon needs it for design reasons, you can add a second arm – press it into place on the backside of the body and make sure it sticks out a little farther so you can see it.)

Well he looks naked, doesn't he? We'll fix that! Embellishment time! Add more gears and stacks of gears and little bitty screws and random dots pressed into the clay for some reason.)

Now, how about some spikes on his back? That would look sweet. I have some little brassy dangles that would look great, but they're hard to find, so instead of making you sad cuz you don't have any, I won't use them and instead we'll make some clay spikes together. Isn't that nice of me? (Actually, I can't seem to find where I put those little brass things, so I'm not really being as nice as I was pretending to be. shhh, don't tell anyone, I have a reputation to keep up you know).

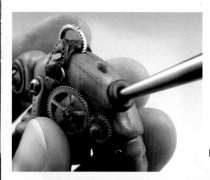

Ok, so first press several holes into his back (three is a good 'several' in this case, by the way). Next roll out three little balls of clay – about the same size as the little eyeball balls. Use a contrasting color clay (the same color as the leather strap is a good choice). Press the balls over the holes, flattening them (the balls, not the holes). Use the same tool to make the hole again through the flattened ball.

To make the spike, get a bit of brassy clay (or silver if you prefer) and roll it into a little ball. Form the ball into a rice shape.

Press the spike into the hole and push down to attach. To make it more spike-like, push down the clay with your finger and thumb pinched to make a cone shape out of the clay – rotate your pinchy fingers around the clay to shape it evenly all around. Hey, spikey!

To heighten the look of metal, you can brush some gold mica powder on the tips of the spikes – front and back.

Look your lizard all over – any additional gears or screws or spikes needed? Hmm, how about a few dots of clay pressed on his head so he doesn't look bald? Or you could give him some head spikes.

> Head spikes are what all the best dressed lizards are wearing this season, don'tcha know!

And he probably needs some texture to minimize the areas of blank clay which still probably look a little naked. Use the blunt point of a tool to press in some dimples here and there - on his back, shoulders, forehead….

A touch of powder as needed to make the design pop – some antique brass maybe on the shoulder and back, a little antique silver down the tail?

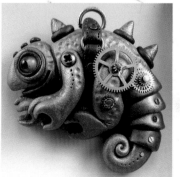

Now it's ready to bake – the usual 45 minutes – 1 hour. Let him cool completely and then use the acrylic paint to add a patina. Use dark brown or dark green or even dark blue. You're a pro at that already, right?

Chameleon done!

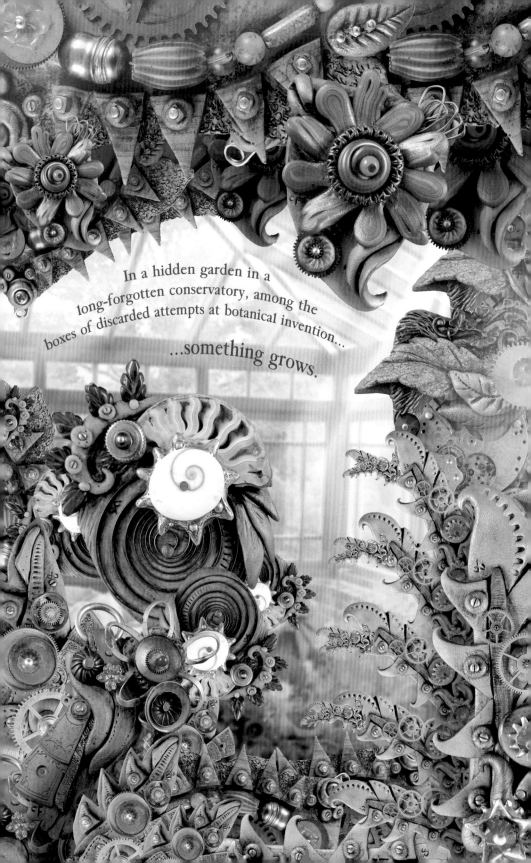

In a hidden garden in a
long-forgotten conservatory, among the
boxes of discarded attempts at botanical invention...

...something grows.

This project is a pendant, but it can just as easily become a brooch, a wall piece, or a decoration for a covered box or vessel. Let your imagination bloom.

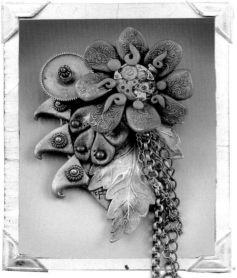

CLOCKWORK ORANGE

FOR THIS PROJECT YOU WILL NEED:

. polymer clay green mixes, flower petal colors (just read the first paragraph of the project for a bit more information)
. 16 gauge wire (or thicker): about 2-3 inches
. one decorative metal leaf about 1.5 - 2 inches long (substitute: 2 or 3 smaller metal leaves)
. headpins (ball-tipped if possible): about 4
. headpins regular heads: 1 or 2
. wire: 28 gauge, about 2 inches
. wire: 16 gauge
. 4-6 small decorative metal rings: about 2-8mm (substitute: beads, decorative-headed brads, small gears)
. mini brads: 4 - 5 (substitute: headpins or screws)
. 4 - 5 assorted pieces of jewelry chain: antique colors preferable about 1 2 inches long each
. one entire small watch with no face, gears exposed (substitute: a decorative glass or metal button, a lampwork glass bead or and interesting gear or metal found object)
. gears - one large (aprox. 34ths inch) or several smaller gears
. decorative stamp pattern (see Resources in the back of the book for the one I used)
. mica powders: gold
. acrylic paint: brown (burnt umber)

Gather your clay blends, any greenish colors of course for the leafy bits. You may have some leftover greens already, if not, experiment with combinations of gold, silver, any green clays (green pearl, sea green, fluorescent green), yellow (any yellow), pearl and ecru. You'll want two or three greens that contrast enough to look different next to each other, but still look nice together. Besides greens, you'll also need a flower petal color. I chose a deep reddish orange

(a mix of red pearl and orange), but your flower can be any color you want (except lavender, - that would be stupid… no wait, lavender is a great color for flower petals. You know what, just go with any color you want). Pick one of your greens for the base of this

pendant. Roll it through the pasta machine at the widest setting. Use your cutting blade to slice a fun leafy kinda shape – I suggest something wider at the top than the bottom and swoopy - like a curvy triangle or a moon with no head – that kind of thing.

Now use your fingers (or your toes if you're really flexible) to smooth the cut edges all around.

If you're going to be making a pendant, then you'll need to add a thick piece of wire at this point to hold a channel open for stringing later. If it's going to be one of those other things, ignore this step. Any uncoated piece of metal will work just fine – at least 16 gauge or thicker will work. You'll need a piece that is just a bit wider than the clay it's going to lay on. The wire should lay on the top of the clay, close to the top of the shape. Roll out a little log of clay that is a little less wide than the clay. Flatten it a bit in your fingers and lay it down right on top of the wire. Press it firmly in place on top of the wire and then use a tool to smooth it onto the base clay. Keep smoothing the whole surface of the clay if you want.

Use one of your other green mixes and run that through the pasta machine at the widest setting. With your blade cut out a strip at least half an inch wide. Slice at angles to create three little triangles. Aren't they cute?!

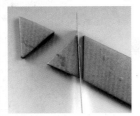

With your fingers, press the shorter side of the triangle (it's the base of the isosceles triangle you just made, in case you were wondering - this will be on the quiz later). Press it so that it curves a bit. Now bend the triangle down, as if it were melting. No, wait – as if it were a fang!

Press the melty triangles to the base clay so that they run along the outer edge (either edge – your choice!) If you want to, you can curl the tips.

Next we're going to add some accents to the triangles to make them look like they've been attached there with metal (of course, it's a steampunk thing, duh), but we'll need a little bit more clay for the attachment since it's kinda thin and we don't want the wires to stick out the backside. Roll out some contrasting balls of clay and stick them in the middle of each triangle.

Triangles are my favorite shape. No, wait,... Circles are. Sorry.

Use a headpin to stack up some fun metal bits (I used two rings and a ball-tipped headpin).

Trim the excess wire, bend over the tip into a hook, and press the embellishment stack into place. (If it does go through to the backside, just add another ball of clay back there to cover it.)

If you have a metal leaf, that's going to look good in the design. I suggest a large one, but if you don't have that, a cluster of smaller ones would work well too. Age the metal using one of those handy dandy metal-aging techniques we talked about earlier in this book. You can also use pliers to bend the leaf into a bit more lively shape if you want to.

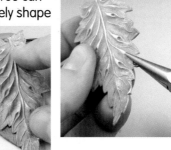

Press the metal leaf into the clay. No need to secure it since we'll be making another clay leaf to help secure it.

Let's make another clay leaf! Roll out a ball of green clay, about the size of a grape (one of those round, red grapes, not the long greenish ones).

Shape it into a blunt teardrop and flatten it with your fingers. Keep it pretty thick.

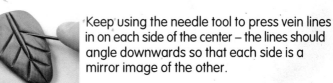

Use a needle tool to press lines into the center so it looks like a center vein – two lines intersecting to make one line (like a "Y" on a diet). Remember to hold the tool very close to the surface of the clay and impress the lines, not scratch them.

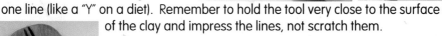

Keep using the needle tool to press vein lines in on each side of the center – the lines should angle downwards so that each side is a mirror image of the other.

Ok, so that looks pretty boring, huh? Don't worry, we're not done yet! Now use a tool (my favorite tool again comes in pretty handy for this part) to press an indentation in at the edges of the leaf where each vein ends. This will make the leaf look notched, which is a good look for a leaf.

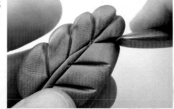

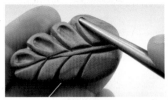

Now use a tool with a rounded end (well, what do you know, it's my other favorite tool! Have you noticed that these tools seem to come up a lot in casual conversation? Obviously, I love these tools and think you will too, but there are a lot of other things you might have lying around that will work just fine! Lest you think this is all a big, long infomercial) … where was I? Oh yeah, take a tool and roll it into the end of each section of the leaf to make a rounded indentation. Use your fingers to press down into each indentation to widen them and make them shallower.

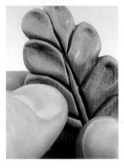

Let's make this leaf a bit more metallic-looking so that it goes nicely with that brass leaf we put in earlier. Use an antique-gold mica powder and brush it into the indentations.

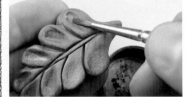

Hmmm, how about a few little dots along the veins – that looks a bit more mechanical (that little "looks-like-riveting" trick again).

Press the leaf on. I think it looks good wrapped over the edge of the metal leaf and over the backside.

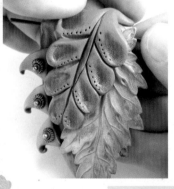

Mini brads pressed into the ends of the indentations of the clay leaf look great, don't they? You should do that to yours, too. (You'll probably only be able to add them to the one side since the metal leaf is in the way on the other side, but that's ok, it still looks good). Don't forget to bend at least one side of the brad's prongs into a hook.

Hey!

The fancifully engraved bar on the side is from a vintage pocket watch, its floral motif fits right in with this piece. The color in the crystal and enameled disc in the center gives the piece a floral feel.

Who ripped this page?

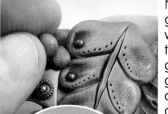

Next we'll add a gear. Roll out some little balls of green clay and press them onto the base where you want to add the first gear. This raises the level of the surface for the gear so it can float nicely and not get squished down all into the leaves. Find a fun gear from your stash and stack it on a headpin (add a few smaller gears first if you want to). Trim the pin and bend the tip as usual. Press the headpin with its gear stack into the clay balls firmly but not smooshingly.

Nice.

Let's make the flower now! Let's get some color in there - a deep orangey-red would be fun, don't you think? (I had to make them orangey so I could use that cool title for the project – you see I had no choice, right?) Once you've made a color you like, roll out some little balls (about the size of a big pea). Make seven or eight of them. Shape the balls into teardrops – long and narrow-ish would be best.

We could leave the petals smooth, but where would the fun in that be? So let's press each one against a patterned stamp to leave an interesting impression on the surface. All kinds of stamps could provide an interesting pattern – all you need is a narrow area that looks intriguing. This is a fun ancient Chinese pattern stamp with a nifty pattern in the center that I had (check the back of the book in the Resources for info on this stamp if you like it too).

Take your teardrop, press it in your fingertips to flatten it just a little. Press the petal firmly into the stamp and peel it off (if your stamp starts to stick, you can spritz the surface of the stamp with water as a release). Doesn't that look cool!

Trim off the pointy bits – we don't need 'em.

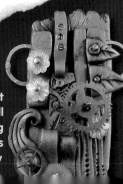

The brass loops at the top are decorative as well as functional (the piece can be strung as a necklace from them). The half-leaves at the top right are screwed in, which really adds to the steampunkery-ness of the piece.

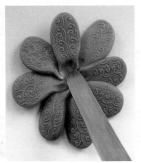

Roll out a little ball of clay (use one of your greens). Make it about half the size of one of the petals. Flatten it and then press the petals onto the green clay all around, like… uh… flower petals.

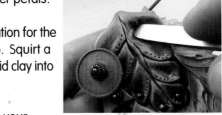

Make an indentation for the flower to go into. Squirt a little bloop of liquid clay into the indentation.

Press the flower into the indentation – use your finger or a tool to push it in by pressing the center of the flower into the hole – see how that makes the petals cup a little.

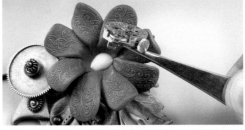

Obviously we have to add a little clock-face in the center of the flower – it's in the title of the project, after all. I used a small little clock with all the gears and inner bits all taken out and the face off it – a watch skeleton. Use a headpin through one of the little holes in the watch (trim the excess and bend in a hook, just like always). Add a drop of liquid clay to the center of the flower and press the clock in firmly (the liquid clay will squinch all into the inner areas and help hold it in more firmly).

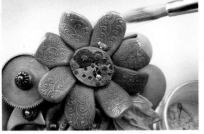

How about a touch of color to the petal tips? I chose gold mica powder.

Time for chaingles! (chain dangles. duh.) Cut a few different types of chain into 1-2 inch lengths. Snip off a bit of wire (28 gauge will do) and thread the chains onto the wire through their top links. Bend the wires up, hold them together with pliers and twirl the chain wad to twist the wire firmly. Trim off the excess, leaving about half an inch of twisty. Bend the end into a hook.

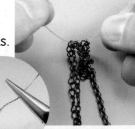

Wrap a little wad of green clay around the twisty wire and onto the chains a bit. Form the clay into a little stem.

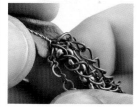
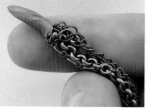

The chain is going to slip in under a flower petal, but first you have to decide exactly where – remember that gravity rules, so you know wherever you put it, it will dangle straight down so figure out where it will dangle delightfully. Then lift up the petal, use a tool to poke a nice "stem" sized hole into the clay behind the lifted petal. Squelch in a little bit of liquid clay and then press that clay stem in good and firmly (don't be afraid to use a tool to press it in good). Lay the petal back over the chain to cover any messy bits. Yay! Chaingles!

I don't think that "chaingles" is a real word.

One last detail to add to the flower before we're finished – a bit more orange flair is needed I think. Rummage around your messy workspace until you find a little blob of orange clay. Roll out some little snakes of clay, roll both ends so that they're pointy. Use your fingertip to roll one tip into a curl. Press the finished coil onto the petal with the curly part against the clock. Make more for each of the petals (well, you can use a couple dots of clay pressed into place for variety if you want to, I did).

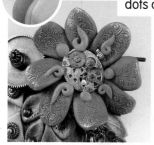

Look the piece over – does it need anything else? Now's the time! Ok, bake it in the preheated oven at the usual temperature for the usual time. I suggest that you use some tissue paper to prop up the petals so you don't have any droopage (it's that gravity thing again). Once it's finished baking, let it cool completely.

Let's get that wire out of there, it's served it's purpose. Don't use your fingers – that never works (ok, it sometimes works, but only if the wire is already loose). Grasp the wire with pliers and hold the pendant with your fingers (somewhere that won't get hurt from being held). Turn the wire with the pliers (you'll probably hear a little "snap" as you break the grip of the clay), then ease the wire out by pulling firmly with the pliers. Pull straight out. Usually it eases out a little at a time, so be patient.

Oh, snap!

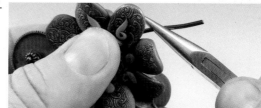

Finally, let's add a patina – you know how. I used a very dark brown on the petals to create maximum contrast which makes the clock face pop out (visually, not actually). A less intense brown on the leafy bits is probably a good choice.

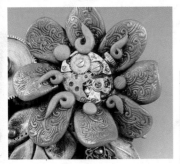

Let the paint dry, and that's it! All done! That one just went like clockwork, didn't it? (Well, you knew I was going to use that pun eventually).

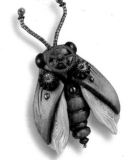

Don't bug me! No, wait… do! Steampunk bugs are great fun to create! Visit my website for a downloadable project to make your own!

Same idea, different details. The petals around the clockpiece are shorter and rounder, and the pendant back is more simple.

GUEST ARTIST
Eugena Topina

Steampunk doesn't need to be gritty. This is a perfect example of how classy and refined the steampunk look can be. Resins trap the gears and filigree to give this piece glamour and shine.

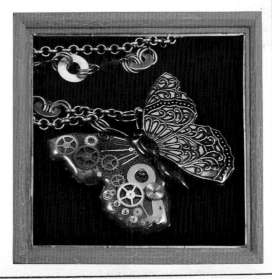

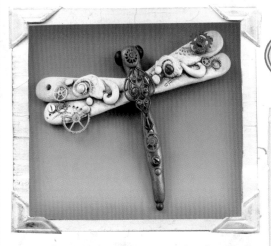

FOR THIS PROJECT YOU WILL NEED:

.polymer clay: white, silver, gold, purple, black
.filigree finding
.several headpins, including a decorative one (substitute: regular headpin
.assorted gears, screws, steampunk embellishments
.mold of a vintage embellishment
.mica powders: gold, purple
.acrylic paint: brown, purple

Dragonflies are fun to steampunk – they look so good with gears! This zippy fellow can be a bead or a brooch, or just make a whole flock of them to embellish that bit of wall over the bathroom mirror.

We'll need a bit of white clay for the wings, of course. The body can be any color you want – I mixed mostly silver and a bit of gold with just a snippet of purple thrown in. You can add more purple if you want to make the color more dramatic. Oh yeah, you'll need just a little bit of black clay for the eyes.

Roll out a log of clay using the body color mix – about 2 inches long or so. Push one end down with your fingers to fatten it a bit more. Shape that fatter end into a bit of a ball. If you hold the body about a quarter of an inch from the top and squeeze all around, that will make the ball of the head more distinctively headlike.

Now use your fingertips to roll the rest of the body as thin as that squeezed bit under the head. It should look sorta' like a big, long matchstick – one of those old-fashioned wooden ones.

Take your time to make the shape right. If your dragonfly looks too long, you can pinch some excess off the tail. If he's too short/fat, roll the body thinner. There you go, just right!

For the eyes, we'll just roll one ball of black clay, cut it in half and then press the cut sides of each half against the head. This works better than pressing on two small

balls of clay since the balls tend to turn into pancakes. The half circles stay roundish (which looks much better). Use your fingers to press the clay on gently, pressing mostly around the edges to keep that roundness round!

Ok, on to the wings. First, clean your fingers or you'll get body and eye color all over the white clay.

FROM THE DESK OF PROFESSOR CONTRAPTION

This reminds me of the time I once created a flying machine, coincidentally in the shape of a large dragonfly. Of course, when I say that I 'created' it, I mean that I designed it, in the sense that I thought about what it might look like and how the faces of those men in the Royal Society of Serious Scientists would be frozen with disbelief and amazement at my sheer cleverness as I flew the marvelous machine over their Clubhouse. Hahahaha! That'd show them for not letting me become a member!

Here's a sketch of the idea I jotted down on a napkin I stole from their stupid club.

Roll out four balls of white clay, all about the same size (about as big as those little gumballs, you know the ones).

Now form them into long, narrow teardrops and flatten each tear drop with your fingers. They should be this thin:

No need to worry about fingerprints, touch the wings all over! Fingerprints overlapping each other make a nice, organic texture (of course just one thumbprint blapp in the middle of the clay by itself looks pretty silly, so don't do that, do the touching all over thingy).

Dragonflies have two wings on each side of their bodies. If you check up on this fact, you'll see it's true. It would be silly if all the wings were on one side. They'd fly around in circles all the time. So, lay one clay teardrop wing over the other to make the top and bottom wings for one side (then do the other side – make sure it's facing the other way).

The bottom wing can be a little skooched in so that the top wing sticks out farther. I think that looks pretty nice. It's not technically accurate of course (dragonfly wings don't really overlap like that but the overlapping helps stabilize them so let's go with that).

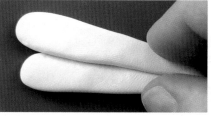

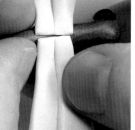

The wings should be as long as the body from tail to neck.

Now trim the tips of the wings off. Press them onto the body, right below the head (that's the thorax in case you were wondering… that's going to be on the quiz).

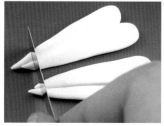
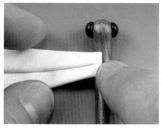

Now pinch the body immediately below the wings to make that slender waist that every dragonfly wants to have.

It's a good idea to add another bit of clay on the back of the wings to strengthen the connection. Where the wings attach to the body is the weakest point in the piece, so reinforcement at this point is necessary. Roll out two small logs of white clay and flatten them with your fingers, then press them gently onto the back of the wings. Flip the dragonfly back over and press down from the top to attach those bits (that way you don't accidentally mush the front of the wings).

Roll out a little oval of clay, flatten it, position it over the front of the wings to cover the ends, and press on. Doesn't that look much nicer?

For the next part, I used a wonderful little reproduction vintage filigree piece (check the back of the book for source info). I liked the airy Victorian feel it gave the piece. If you don't have a piece that looks like this, you can substitute any bit of filigree, a bit from some costume jewelry, some fancy wirework, or a watch gear (we'll use more gears in the wing embellishments, but another one on the body wouldn't be bad!)

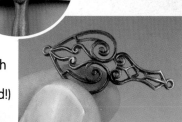

This piece has several places where I could slip a headpin through (trim the end and bend it over to help secure it into the body). Which I did, obviously (making sure that the pin wasn't too long so it wouldn't poke out the back of the body – dragonflies don't like that.

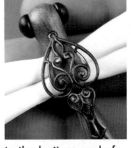

I covered the top of the piece with a little ball of clay – to hide the tip, but also to give myself a nice pad to add a gear (on a headpin with bent-over tip).

Aw, let's add a gear to the bottom end of the filigree, too! Another little flattened ball of clay to give a bit more thickness and then press in the gear. (This is one of those gears with no center hole for a headpin. So you can just press the gear into the clay, bake the piece, then pop the gear off, add some glue (jeweler's glue or super glue) and push it back in. That's the best way to handle little gears like this).

I felt like using the same trick for these wings as we used in the hinged heart project – pressing a bit of clay into a mold of a vintage embellishment (you can start with a small ball of clay to press into just a section of the mold),

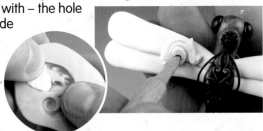

then press that bit into the wing. Definitely adds a nostalgic flair, doesn't it? I used a dowel tool to press the piece on with – the hole left behind can be used as the guide hole for an old screw.

Now continue to add clay embellishments – curls and dots and molded bits – on the wings and on the body, too.

A few more things will finish the wings – how about using the edge of a gear to impress an interesting pattern? Fun, huh? You can also push an entire little gear into the clay, then gently pull it off with tweezers or the tip of a blade to pry it up. When the patina gets added, those impressions will add to the whole steampunkery feel of the piece.

Correct!

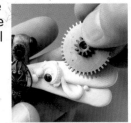

Oh, we'll need a way to hang this guy if he's going to be a bead or a wall piece, so use a tool to press a hole into the upper wing on each side.

Hmmm, his bum looks a little boring. How about a decorative headpin to liven things up?

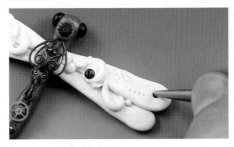

Ok, now for the fun part!! Adding gears to the wings! Position them in clusters for the most effective look – a grouping of several gears together looks more 'functional' than just a scattering of gears over the surface. Remember that you can raise the height of a gear by adding a ball of clay before pressing in the gear. You don't have to always use a full gear either, snip some of the gear off and imbed it into the clay for variety.

Once the wings look groovy, add just a bit of mica powder for that final touch of color! (I used purple and gold powders – sweet).

Now is the time for any final touches -- angle the wings up a little, curve the body – and then it's time to bake. The usual temperature, and bake for 30-45 minutes. Cool completely.

A patina added after baking and cooling will bring out all those great details in the wings especially. You know how to patina now, you're a pro at this, right?! Use a very light brown in the wings. Let that dry and then use just a bit of purple paint. A dark brown is best on the body.

Ok, your flying machine is ready for takeoff! String him up through the holes in the wingtips, or add a pin to the back if he's going to be a brooch (see the back of the book for a how-to if you need it).

This is what happens when embellishments take over! The over-abundance of details actually works because the colors used are very close in tone – too much color would be one thing too many. The interior of the wings are sheet mica – just cut the mica into wing shapes and wrap clay around the edges, then embellish!

I've used very few actual gears on these wings, but all the impressions of gears pressed into the clay accomplish the same thing, just in a different way.

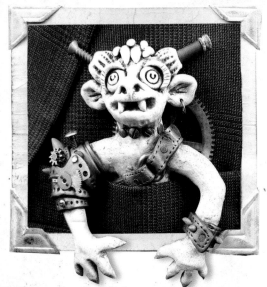

FOR THIS PROJECT YOU WILL NEED:

. polymer clay: white, silver, gold, black
. liquid clay (Translucent Liquid Sculpey)
. embossing powder (anything dark-colored)
. wire: 18 - 16 gauge (about 5 inches)
. two embellishments for horns screws or posts or nails
. ringwire loop (for earring)
. assorted screws
. acrylic paint: brown, dark blue
. assorted screws and emblishments: at least one large gear (about 1.5" wide)
. large jump ring (substitute: circle of wire)

In their natural habitat, gargoyles have many functions – waterspouts, architectural ornaments, protectors against evil, cute singing characters in animated movies – it's a rich profession.

The gargoyle we're going to make will of course have some steampunk elements in his design, but he also can add to your own steampunkishness. Lots of folks cosplay (it's a whole dress-up kinda thing), and steampunk is a popular look. This little gargoyle can slip into a pocket of your own steampunk costume, (if you don't cosplay, there's always Halloween parties!) Or slip him in the band of your top hat – that's sure to get attention!

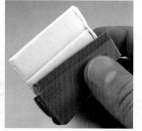

Most real gargoyles are carved from stone, so we're going to mimic the look of stone in the clay mix we create for this project.

Start with a mixture or white and silver to get a nice grey (add more grey or black if you want it darker, add brown for a brownery color).

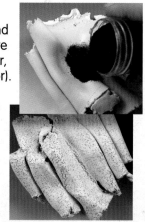

To get that nice flecked look that just says 'granite!' we're going to add a wad of embossing powder – any dark powder will work just groovily. Pour it into the center of the clay blend. Fold the clay over the powder carefully and massage the clay with your hands to help smoosh the powder into the clay. Then you can run the wad through the pasta machine – carefully still or poof! the powder will get everywhere.

Take some of the clay mix and roll out a long log, about 3 inches long. Flatten it with your fingers so that it's a little less than 1/4 inch thick. Isn't that a weird way to start a gargoyle? You're probably just now thinking that, huh? Like, "What the hey? How is this a gargoyle shape?" Although you may have used a different phrase. Actually what we're going to do is make a gargoyle head, shoulders and arms connected to a flattish strip of clay – the strip slips in your pocket to stabilize him so he can be hanging out all casual-like. Clever, huh?

Next, roll out a ball of clay for the head (about the size of a small chocolate truffle….mmmm, don't mind if I do! I'll be right back…… ok, munch, munch… smack). Press the ball on to one end of the strip and blend it in with a tool. You can leave some of the tool marks showing if you want – it's supposed to look like it was carved from stone, right? so some "carving" marks are visible.

Egads!

Squeeze the front of the ball to form the snout – pinch gently all around so he doesn't turn out to be a duck!)

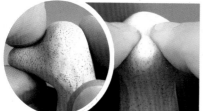

To make the indentations in the face where the eye sockets are, just press with your fingertips (if you have fancy nails, that's going to be an issue – you'll poke his eyes out… use your knuckles instead, or go borrow someone else's fingers for this part).

The indentations are large, gentle impressions. To make the actual sockets for the eyes, use a tool to press holes in the center of each indentation.

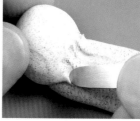

We're going to do something a little different than what I usually like to do for the eyes on this dude. Normally, I'd have us wiring up some beads for the eyes, or using those nifty glass eyes, but since this guy is supposed to be a gargoyle, we're going to stay a little closer to the traditional look with all the features made from stone – or

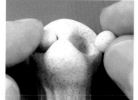

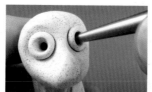

at least looking like they are. So roll out two balls of clay, large enough to fill the socket holes and place them in. Use a tool to poke holes in the center of each one.

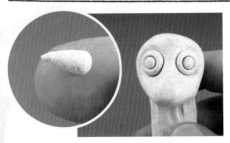

Roll out two tiny balls – these will fit inside the holes we just made. Form the balls into teardrops and press the teardrops, pointy-sides first, into the holes.

Here's a stone-carver trick, carve out a little crescent to look like a wide-eyed pupil.

That's enough on the eyes for now. Let's add a wire to the strip of clay that will support the arms later on. Use a piece of thick wire (I used a 5 inch piece of 16 gauge steel wire). Center it just below the neck (at shoulder-height) and press the wire in slightly. Roll out a little snake of clay, cover the wire across the chest and blend it in smoothly.

Back up to the face – it's mouth time! Use a needle tool to press a line in right through the center of the snout. Widen the mouth with a larger tool. Just pretend you're a dentist and poke it all around in there.

Unless you are a dentist, in which case you don't even have to pretend!

There are a lot of ways we could go with the nose – human shnoz, bird beak, dragon snout, but I just felt like a sorta' doggie thing. Start with a small oval of clay, very carefully, pinch a point into each end to make it look like a sharpened football (I have big ol' dorky fingers, so if I can do it, I know you can too – it may take a couple tries, but that's ok – you're not going anywhere for a while, right?)

This next bit is the hard part – pinch another little pointy part on the bottom, centered between the two pinched ends. It should look like a weird "T".

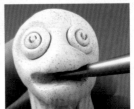

Press the "T" nose on the front of the snout, make sure you gently push all the tips down to attach them. Use a tool to blend only the top of the nose into the clay at the top of the snout.

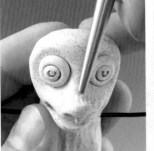

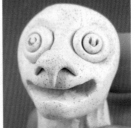

This actually looks like my cousin Thaddeus.

Teeth next! Just two fangs will be enough, I think, although if you're still in 'dentist' mode, you can do more. First poke two holes in the roof of his mouth, then add a dab of liquid clay in each hole. Next, roll out two small rice-shaped bits of clay and press them into each hole. Wipe away any drips of liquid clay. Perfect!

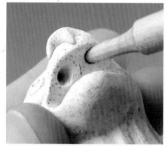 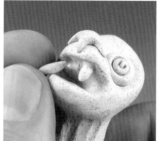 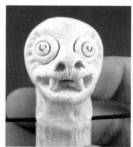

Lot's of gargoyles have horns (it's a peer pressure thing). Let's make ours a bit more steampunkish. Start with small balls of clay pressed into both sides of the head towards the top.

Now screw in some screws, or press in nails or rods – whatever you have that you think would look cool. I had a nifty curved metal bit from a vintage pocket watch, but I only had one, so I went with these straighter thingys instead. They don't have to be identical, just similar. Add some texture to the clay if you want to, and pinch the ends of the clay more tightly around the horn embellishments.

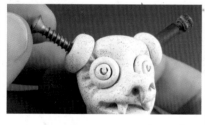 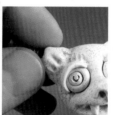

Hmmm, the eyes need something, he looks a bit too caffeinated. Eyelids will calm him down. Roll out a small log of clay. Press it flat and curve it. Press it into place above the eye balls and gently blend into into the face. That's better.

For the ears, just roll out two little egg-shaped clay bits and press an indentation into the center of each with a tool (guess which tool works great?)

Press three parallel lines inside the indentation and then pinch the shape at the narrower end.

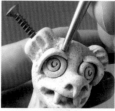

Slice the excess clay away where you pinched it, press the cut edge against his face right under the horns, and use a tool to blend the clay into the head. Obviously do the same thing to the other clay blob to make the other ear.

 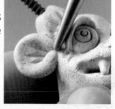

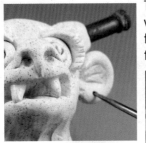

This dude has style, so poke a hole in one ear lobe so we can add an earring later. (This is something my friend Cindy does to her clay creatures often, and I thought it was a great idea to do here. So, thanks Cindy!)

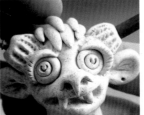

Leave your gargoyle bald, or add snakes of clay for a lovely stone toupee.

I thought the ears looked like they needed to be pointy – he was a bit too doofus-ish with round ears. Just a little pinch will solve that.

Look him all over and finesse, fix or add anything you want because we're going to give him a bake before we move on to the arms. I pressed in a line up of screws around his neck (he's related to the Frankensteins).

Bake for at least 30 minutes at 275°F (130°C) and let him cool completely.

Once he's cooled down, we can add arms. The reason we do it this way is that adding all the arm details while the other clay is still soft would put a lot of pressure on the rest of the piece and you'd probably get all cranky, having to fix knicks and smooshes and places where the stinkin' fingers would keep getting stuck to the friggin' body… we don't need that.

Ok, so now let's bend the wires in the way that we want the arms to be shaped. He's going to be loitering in a pocket, remember? So we need shoulders out, arms akimbo (that's a cool word, huh?) and hands down.

Personally, I find words such as "Akimbo" quite distasteful.

Start by making a bit of shoulder – bend the wire down a little more than a quarter of an inch from the body on each side.

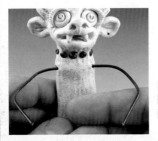

Now the elbow bend, a half inch or so further down the wire-- it should be almost a right angle bend.

Roll out a log of clay (about the size and shape of those bubble gum cigars you get when someone has a baby). Cut or press the end so that it's flat (the other end should be round). Use a needle tool to poke a hole right through the center so the wire knows right where to go (wire can be a little stupid).

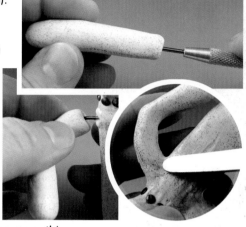

Slide the arm onto the wire, slowly taking the turns of the wire. If the arm clay has trouble, pull it off and make the center guide hole a little wider by rolling the needle tool around a little.

As the arm gets close to the body, squoosh a little bit of liquid clay around the connection zone to help the fresh clay adhere to the baked clay. Use a tool to blend the arm onto the body (add more liquid clay to the body if you need it to make the blending smooth).

We can't have him stay all noodlely armed like this, so squeeze at the elbow to make a sharper bend.

Squeeze at the wrist to shape that area more more realistically as well.

The clay that's left should be just large enough for his hand to be formed – if it looks like he's dangling bowling balls, then pinch or slice off the excess clay and smooth the remaining clay back into a mitten sorta' shape.

To make the fingers, use a blade to slice three slits into the mitten – one in the middle and one on each side, dividing the shape into four equal parts. We're going with the Gargoyle Carving Society's approved four-finger option. (There is no such society, silly).

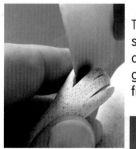

Use a needle tool to separate the fingers and get rid of the cut look.

I am a founding member of the Gargoyle Carving Society, by the way. I wish someone else would show up to a meeting sometime.

To make the cuts look like fingers, gently grip the clay, one finger at a time, and twist slowly while pressing down slightly. The twisting helps smooth away the squared edges and the pressing down helps the finger from getting too thin. It doesn't matter at this stage how long the fingers become – they won't be even, since the cuts are never exact. All we want to do is to make each finger about the same thickness. Use a tool to clean up any messiness between the fingers.

Ok, once the fingers look about the same width, then we can cut or pinch off the ends to make them all about the same length. Pinch the tips into little points – gargoyle claws.

Prop the hand up a little with a piece of rolled-up paper. We don't want the fingers to touch the body and stick to it – the arms need to be held out a bit so the finished

gargoyle can slip into a pocket with the body slab inside the pocket and the arms outside.

Move on to the other hand, now that you're a pro at fingers! (Actually, it usually takes doing about 5 hands for you to be a pro at fingers, so don't worry if the first try didn't work as well as you expected – just make one and a half more gargoyles!)

To be a pocket protector means a bit of showing-off in the accessory department, so how about a nice buff wrist cuff? If you have a bit of the antique brass clay mix around, that's a good one to use (or make it by combining black and gold clays). Run the mix through the pasta machine set a few notches narrower than the widest setting. Cut out a strap – gargoyle bracelet sized – and wrap it around the gargoyle's wrist so that the overlap is in the front.

Use a needle tool to add the fake stitches around the edges. Use a trimmed headpin to "connect" the band together.

How about a few spikes for a real impressive wrist band? Start by poking holes in the strap with a tool-tip, adding a drop of liquid clay to each hole, and pressing in a rice-shaped bit of clay (I suggest using a nice bright gold color).

He needs more embellishing, don't you think? Yeah, me too.

How about a nice shoulder strap? You know how to make one (same way as we did in the chameleon project). I decided to use the same 'old brass' mix as I used on the wrist strap. You can use whatever you want... except purple. Purple is out.

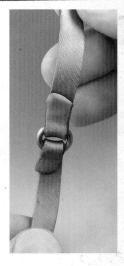

Since we're adding this to baked clay, don't forget to dab just a little liquid clay along the underside of the strap before you drape it over his shoulder, so it'll stick on. Position the buckle up close to the neck so that it won't get hidden when he slips in a pocket.

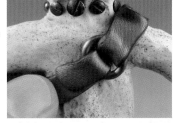

Ok, so here's the dealio – since this guy is a pocket protector, he has to look a bit protective. He's got the spikey wrist thingy, so that's good. But he needs more - how about a large gear on his back as though his shoulder strap was securing some ninja weapon or something. Gargoyles can be ninjas. . . right? You'll need a large gear to make that look good (about 1.5 inches or so). Just press the gear into the strap on the back, and add a bit of clay over the gear's center and pressed into the strap – that'll hold it in place. Looks cool, huh?

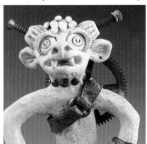

How about a serious-looking bit of elbow armor? Yeah! Start with some strips of clay overlapping (this is the same trick as we used on the chameleon's tail). As you go around the elbow bend, you'll probably have a gap. Don't worry – just cover that gap with a little oval of clay, flattened and pressed on. Ooh, then add a little spike (hey, look at that – another trick from the chameleon project).

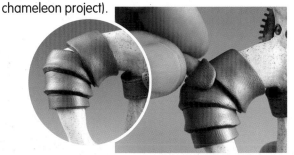

Yes! Now he begins to take on the appearance of a steampunk creature!

Now go crazy! Add screws and gears and any embellishment bit that looks interesting. Since the clay is not thick, you may have to add small balls of clay to any area that you want to add something with a headpin to hold it in place (and you'll have to trim the headpin shorter than usual – if any of the gears are wobbly after baking, just use a dab of glue to stabilize the piece).

Now he looks protective!

Time to bake him one last time to fuse all the parts. Bake at the usual temperature for 45 minutes to an hour. Don't forget to prop his arms up with paper, and prop any other parts of him that need to be supported, too.

Once he's baked, then cooled completely, it's time to add the patina. This step is really important for this project – the "stone" needs to look old, and there's nothing like an antiquing of brown and brown-blue acrylic paint to bring out the centuries!

Let him dry, slip him into a pocket or hatband …
time to cosplay!!

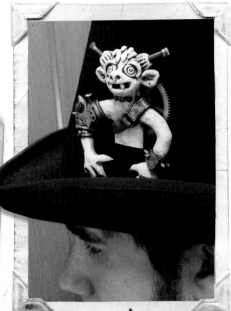

COSPLAY O'CLOCK

FROM THE DESK OF
PROFESSOR CONTRAPTION

Cosplay, or 'Playing the Costumes' is a tradition that dates back to Egyptian times, when the Pharaoh and his underlings would dress up in fanciful outfits to celebrate Ra's Birthday, All Hallow's Eve, and to attend the Babylonian Comic Con. Top Hat's and Monocles were the costume of choice, which, according to top scholars is "weird" considering Victorian England hadn't been invented yet. I personally suspect time travelers.

STEAMPUNK LINEUP

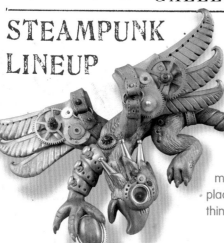

The gargoyle asked some of his buddies to come hang out. Dragon, goblin, gryphon, bat – that's a pretty good turnout. He also invited faerie and chimera, but they already had other plans and couldn't come.

Swooping down on eagle's wings, this **gryphon** snatches the mystic stone from it's ancient resting place. Either that, or it's a nice, shiny thing he picked up from the alleyway.

GUEST ARTIST: Dawn Schiller

Squeezed inside a vintage pocketwatch case, this fellow would be the highlight of any steampunk outfit – imagine pulling him out of the watch pocket of your waistcoat, when someone asks if you know the time. "It's goblin o'clock" you'd be obligated to proclaim. And you'd be accurate.

GUEST ARTIST: Tracey Lipman

The leather look is IN this season, and this guy is ready - decked out in a suit of leather armor that's sure to withstand all perils, and be a hit with the ladies.

GUEST ARTIST: Darleen Bellan

This guy is all packed up and ready to go on some batty adventure! The little knapsack full of steampunkish equipment actually contains a working gyroscope, a sonic screwdriver and fifteen boxes of GuanoLite Bat Snax in five different flavors. Yum.

Yuck.

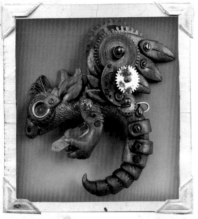

You already know how to do almost everything to create this dragon. The body shape is very similar to the chameleon (and if you want more info on making dragons, I have a book all about dragons – check in the back of this book for more info). The tail is that overlapping clay strips trick that you know how to do so well already. The feathers of the wings are like the triangle leaves in the flower project. The goggles – well, those are in the next project, so you'll know how to add those shortly. The hands are discussed in that project too. So, what are you waiting for? Get started on steampunked dragons next! Yay!

Not all steampunk creations have to be mono-chromatic. Add color to the 'old metal' look with a few well-placed accents. The orange circle is an enameled disc and adds to the well-worn look since it's mottled in coloring. The orange is echoed in the carnelian beads pressed in here and there, and the orange paint used in the patina at the top of the wing. The chain and crystal was added after baking – the wire ring was sculpted into his hands and baked as part of the piece, then the accessory added (just wires and chains all twisted and looped – easy peasy)

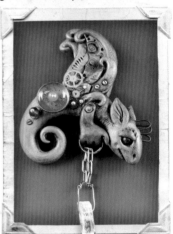

The Daily Telegram
and Morning Post

LATE LONDON EDITION

LONDON, FRIDAY, SEPTEMBER 17th 1897

Local Crackpot Discovers Dragon, Exposes Hoax by Quentin Fillibuster, *Staff Writer*

A well-known local man, Maximillion Contraption, (often seen at the City Park, lecturing to no one in particular), was recently the center of a surprising discovery. While setting up his soapbox and arranging his pamplets, "Professor" Contraption, as he likes to be called, stumbled over an object sticking out of the earth and twisted his ankle. He demanded to be reimbursed for "pain and humiliation inflicted by government lands" at the city council meeting later that day. The site of his injury was

examined by the mayor and several snickering council members, in order to excavate the object. A large bone was revealed. Mr. Contraption promptly announced its identity as a rare, perfectly preserved dragon bone. As word of this spread, the site was visited by several hundred curious townsfolk until it was pointed out by Miss Primm that the "dragon bone" had "Made in China" on the underside. Mr. Contraption still holds that the bone is authentic. "Everyone knows that

dragons come from China" was his reply when asked for an explanation.

continued on p. 87

The only thing worse than being talked about is not being talked about. Also sharks.

Queen declares tea time mandatory
Biscuits Still Optional

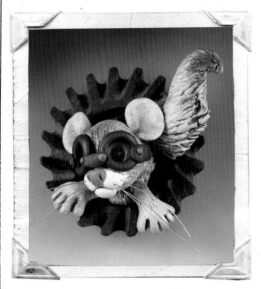

FOR THIS PROJECT YOU WILL NEED:

. polymer clay: white, fuchsia, burnt umber and some of the same mix as the gargoyle project (whitesilver)
. two dark, round beads for eyes aprox. 4-6mm
. 28 gauge craft wire about 4 inches
. sheet mica - about an inch square
. mica powder - pink, antique copper or brown (optional)
. beading wire - thin - xs or .010" about 6 inches (substiture: 28 gauge craft wire)
. something fun for the rodent to peek out of (I used a rusty old mince machine gear, but anything with a small opening will work - an old bottle, can, picture frame, branch with a knothole. You can also use new hardware items, like metal plumbing or electrical accessories and age them - you remember how, right?)
. a small piece of printed paper (preferably something yellowed with age), shredded into little strips (substitute: Spanish moss, shredded packing paper or newspaper, raffia, packing excelsior)
. acrylic paint: light brown

This project works great as a small wall piece. You can adapt him to make a focal pendant or a brooch – just make him a little smaller and choose something wearable for his hidey-hole!

This rodent could be a squirrel, or maybe a chinchilla or a ferret or something – probably a squirrel, though, with that fluffy tail. Obviously he's a flying rodent with those great goggles.

The color for his body should be a brownish grey color – if you have some of the gargoyle mix left, just mix in a little bit of burnt umber clay to make it the perfect shade. If you don't have any left, make the grey out of mostly white with some silver added (then add the brown, duh.)

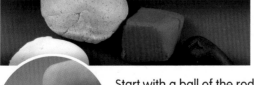

Start with a ball of the rodent color – about the size of a marble. We're going to make the head first, so make sure there's enough of the same clay left to make a little body blob, tail and hands.

Use your thumbs to press indentations into the ball to make the eye socket areas.

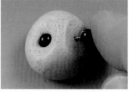

Rodents look wonderfully cute with big, round, dark eyes, so wire up two in the usual way and press them into the center of the indentations – push them into the clay so that the wires are hidden, if possible.

Although there are several ways we could make the snout, this is a nice squirrelly way: use the white clay to roll out a little oval (about the size of medicine tablet). With a round-handled tool, roll an indentation into the middle of the clay on one side. It should look like one of those sleeping masks that you would use to try unsuccessfully to take a nap in the middle of the day. Flatten it very slightly.

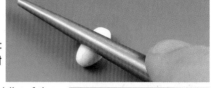

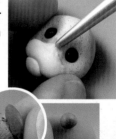

Press the shape (this is the cheeky part of the snout) onto the bottom half of the face, in the center. Roll out a little ball of white clay to press into the indentation to make the chin.

Use a tool to blend the clay from the chin into the face ball clay. I find it easiest to press the edge of the clay down a bit so it's easier to drag little strokes of the white clay onto the face.

Blend the top of the snout/cheeky clay into the forehead. You might find it easier to blend with a larger tool first. You can blend all along the top, but leave everything else alone! No more blending!

I think a sorta' pinkish nose would be fun. If it's too pink, it looks a little too cutesy cutesy, so how about a little fuschia clay mixed with the body color+ burnt umber? Obviously you only need a teensy bit.

Roll out an itsy bitsy ball of the nose color.

The nose is a triangle. To form the ball into a triangle, press it between your thumb and forefinger, with your other forefinger on top – see, triangle!

This will make the triangle fat, so just press it flatter in between your fingers.

Once the shape is groovy, press it onto the white part of the face – with the flat part on the top and the pointy part aiming towards the chin. Don't let the nose go past the cheeky area.

Use a needle tool to press the nostril holes into the nose clay. A line at each edge will do it.

Since this is a flying rodent, it's obvious that he needs goggles. These are such fun to make. Start by rolling out a long thin snake of brown clay (I used burnt umber, but any brown will be fine).

Now loop the snake into a circle just big enough to be the frame of the goggle eyepiece (big enough to go around the eye bead with room all around, but not so big that you can't fit both eye loops on his lil' head!) Use a blade to cut the loop at the crossover point.

Place the circles around his eyes and press gently to attach and to flatten the circles a little.

We'll use sheet mica to make the lenses of the goggles – it works great! It's see-through like glass, but it's thin, and of course can go into the oven when the piece is baked. Use scissors to cut little circles that will fit over the circles you've just created – the circles should rest right in the middle of the circles.

Place the mica lenses over the clay circles (I used tweezers instead of my big, fat fingers). Roll out a tiny little piece of clay to go between the goggle halves, over the bridge of his nose (it should look like a little mouse dropping). Press it in place (and be glad it's not a mouse dropping).

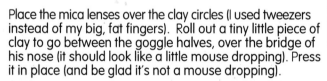

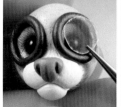
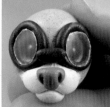

In order for those lenses to stay put, we'll need to add another little snake of clay on top of the first, sandwiching the mica in between. Lay the clay around the bottom circles, overlapping the ends at the outer side of his face.

While certainly very friendly looking, I don't think this rodent has actually earned his pilot's license.

Use a blade to slice through both ends. This will allow you to pull away the excess and the two ends of the clay will touch each other, nice and neat. Press the circles with your fingers to flatten them slightly.

Next we make a strap for each side, to make the goggles look complete – coincidentally, the straps will cover the cut ends of the top snakes, which will hide any messy bits. You can make the straps meet in the back (use that same cut trick to make the ends touch – just don't smoosh any of the front stuff while you're fooling around back there).

You can roll out teensy little balls of brass-colored clay to use as the nails holding the goggles together. You can also use the tip of your needle tool to make all the little stitches (I didn't, for no real reason – I just didn't feel like it).

Time for the mousey/squirrelly ears (they're kinda' more mousey than squirrelly, but they look more funner more bigger so that's whut I done… oops, sorry, went a little hillbilly there for a moment). Roll out a small ball of clay, about the size of a large pea. Flatten it with your fingers.

Pinch one end of the flattened circle together, like an incomplete taco.

Roll the pinch between your fingers to make it into a bit of a stem, then pinch off most of that, just leaving the folded ear circle ending in a point. Make a hole in the side of his head with your tool (or with the power of your mind if you're a master of psychokinesis). Press the pointy part of the ear in the hole. Use a tool in the fold of the ear to attach it firmly. Blend around the outer edges too, if needed, to make the ear look good and hold firmly.

A dusting of pink powder inside the ears looks really cute.

Doesn't Rocky look cute so far?

But he's lacking something… whiskers! I like to use very thin beading wire for the whiskers – it's soft and flexible, just right! Any brand will do – I used a silver-colored wire.

Just snip off six bits of wire – each about an inch long – and press them into the cheek (three on each side). I used tweezers (again, cuz of the fat fingers thing). Don't press them in so far that they poke out the other side of his face, but press them in far enough to be anchored securely. The plastic coating on the wires fuses a bit with the clay when the piece is baked, so that's helpful.

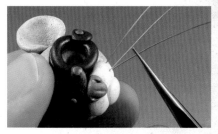

Ok, Rocky the Rodent has a finished face. Time for a bit of body. First of all – did you find a thing with a niche for him to be peeking out of? Good! (I found this cool thing in Australia, it's a gear for a mince machine – it's so delightfully rusty!!) If your rodent is going to hang out in something that can't go into the oven, no problemo – just line the spot where he's going to be with a bit of aluminum foil and continue with the steps, then lift your rodent and foil out of the niche and bake that way. After he's cooled, remove the foil and glue him into place. (Use any craft glue that will accommodate the plastic of the clay and the material that your niche is made out of – I like WeldBond brand glue as a nice all-purpose glue for this sort of thing).

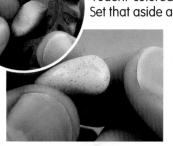

All we really need now is a blob of clay that vaguely resembles a body for the tail and arms and head to stick on to – we're not really going to see much of it. Roll out some of the rodent-colored clay into an oval and press it into the niche. Set that aside and let's make hands.

For cute lil' rodent hands, roll out a ball of clay (about the size of a peanut), then shape it into a bit of a teardrop shape.

Use a tool to press a line separating the thumb from the rest of the hand – now he looks like he has mittens!

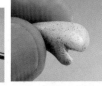

To make the rest of the fingers, just use a needle tool to roll three lines, equally spaced, making four fingers. (This step can be a little tricky – so don't worry if you don't get it right the first time, just roll the clay back into a ball and start again, it just takes a little practice to get to the point that you can make all the lines equally spaced so he doesn't have mutant fingers.

And speaking of mutant fingers... wait, I can't tell that story in mixed company. Also, I forgot what happened.

Make the other hand – remember the thumb goes on the other side this time!

Dust a little bit of pink on the fingertips – sweeeet.

Press the arms onto the body blob as though they are reaching out through the niche. Blend them into the body clay.

Since we'll probably see a bit of the chest, let's use a tool tip to create a bit of a furry texture there.

Scratch some scribbley lines into the center of the body blob in the place that the head will attach. Add a drop of liquid clay and then gently press the head into position. The scribbly lines and liquid clay will help the head attach firmly without you having to press too hard (which might squish the face you've worked so hard on!)

Now switch your attention to the tail. You can go with any number of rodent tail options – long and thin and furry (like a ferret), pink and skinny and bald (like a rat), or fluffy and curvy (like a squirrel). Guess which one I'm going to do? Hey, no fair, you peeked!

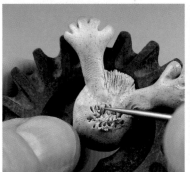

Roll out the clay – for a squirrelly tail, it should look like a big grain of rice – fat in the middle, pointy at the ends.

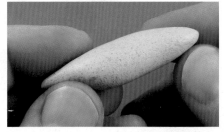

Curve the tail into a lazy "S" shape.

I've found E to be a very hardworking letter.

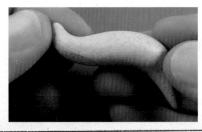

Use a tool to drag some furry lines into the tail, on the outside edge especially.

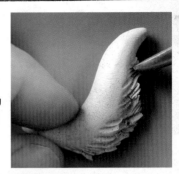

Tuck the tail in place – play with the positioning until it looks right, then use a tool to blend it into the body. Add a dusting of brown powder to the tail tip if you wanna!

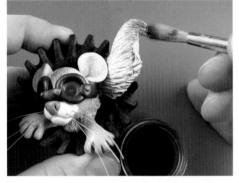

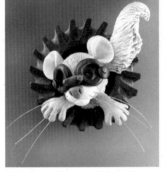

Look everything over and adjust any details. Once you're satisfied, bake him in the usual pre-heated oven at 275°F (130°C) for 45 minutes to an hour. Let him (and the niche he's hanging out in) cool completely.

He's done, well…. there is one more thing you can do that's kinda' nifty. You know how rodents are always lining their nests with shreds of paper? We can add that. If you have an old yellowed newspaper or book, shred a small bit of a page into little shreds. Stuff them around Rocky to make him look all snuggly in his home.

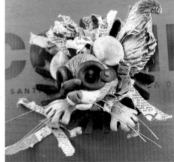

To hang him on the wall, you can glue him to a board (which is what I did), and add a hanger to the back, or you can slip any opening in his niche on a nail in the wall, if the item you used can accommodate that. Or you can add a hanging loop onto the sculpture with wire and polymer, and rebake to secure it (check the back of the book for information on how to do that!)

WHAT A FUN, FURRY FELLOW!!

I've seen funnier and furrier.

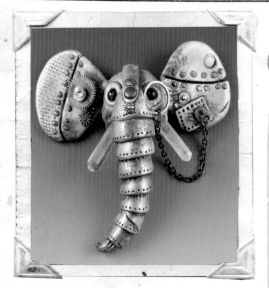

FOR THIS PROJECT YOU WILL NEED:

. polymer clay: silver, white, pearl
. two dark, round beads about 4mm
. small piece of screen (substitute: coarse weave cloth)
. 28 gauge craft wire - about 4 inches
. 20 gauge wire - about 2 inches (substitute: eye pin)
. two long, thin quartz crystals (substitute: stick pearls, metal spikes, nails)
. metal ring - about 10-12mm
. two jump rings
. chain - about 2 inches
. assorted gears, screws, brads, headpins for embellishing
. mica powder: silver
. acrylic paint: burnt sienna (rust brown), burnt umber (dark brown)
. liquid clay
. hinged back straight pin (1 inch)

He's metal, he's an elephant….he's a metalaphant! And he's also a brooch (you don't just have to wear brooches on your blouse or jacket anymore – this one could accentuate a handbag or a scarf or a hat – how fun would that be?!)

Well, the elephant ought to be grey (that way we can add silver powder at the end and really make him look metallic), so mix some silver, pearl and white clay together for a good pachyderm blend.

Roll a ball of the grey clay for the head (about the size of a small hard-boiled egg yolk).)

Use your thumbs to press in two indentations for the eye socket area (whoa! deja vu! Haven't we just done this recently? There's something squirrelly about this!)

Roll out two little balls of clay and place them in the centers of the indentations. Press firmly to flatten them.

Use 28 gauge wire to prepare two beads (about 4mm size) for use as his eyes (you know how) and press them into the centers of the flattened balls.

Monocles are the ultimate fashion accessory. I own 87 of them.

For the ears, roll out two balls of clay – a little smaller than the ball we did for the head.

Flatten the balls with your fingers. While you're flattening them, keep them bowl-shaped (remember the old 'pinch pot' days in high school – well, it's like that, sorta - just not so much bowl-shaped, more like spoon-shaped).

Next pinch one end a little to make a bit of a tab. When you gently pinch a bit on one side, remember to then flatten the tab so it won't be too thick.

Now make a slot on each side of the head for those ear tabs to slip into. Use a tool to drag an elongated hole into the clay.

Press the ear tabs into the slots and blend the clays together to attach.

Let's make it seem like his ears are metal sheets riveted together. Use a needle tool to embed a line in each ear – make the line on one ear go across and the other go down, for variety.

Now for the rivets – which will be little tiny balls of clay. Press holes for the balls to set into - just use the tip of a tool.

A bit of patterning on some of the clay looks good. You can use an open weave cloth, or better yet, a piece of screen. Push it into the clay and remove.

Roll out balls of clay (you can use a little darker blend of clay for contrast), press the balls of clay into the holes.

I prefer hippopotomi to elephants.

You know how metal sheets always have those metal patches on them? No? Well, they do. Let's make one. Roll some clay through the pasta machine at a thinner setting (about 3 notches thinner than the widest). Cut out a rectangle. Press it on an ear somewhere. Use a needle tool to poke little holes around the edges.

Bend the top of the ears – they look better than just flat.

What would an elephant be without tusks? Lame! That's what. You can use a lot of things for tusks – stick pearls, metal spikes, nails…. I used natural quartz crystals.

Poke holes at the bottom of the face, below the eyes, for the tusks to stick into. Roll out two small balls of clay, press them on each hole, then poke again to open the hole through the flattened balls. Push the tusks into the holes.

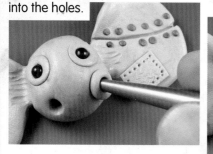

Trunk time. Roll out a long snake – a little thinner than you'd like because we're going to add strips (which will make it thicker). Check the thickness and length against the face and adjust.

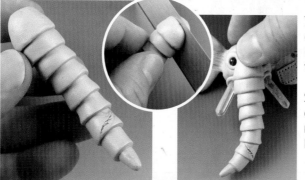

You remember the chameleon tail trick (overlapping strips)? Wrap the trunk in the same way!

Slice the top of the trunk at an angle so that it can lay right onto the forehead. Press it on firmly.

Firmly I say!

Add details to the trunk – poke holes for rivets, add lines at the seams between strips, press in the mesh for patterning.

Obviously the elephant needs a monocle. Start with a metal ring (I used a segment from a chain, but you can use any round metal loop, or make one out of thick wire). Attach a small length of chain to the wire with a jump ring. Just use pliers to open the ring, slip the loop and end of the chain onto the ring and use pliers to close the ring again (there's a bit more detail about this process on pages 82-83).

To attach the monocle ring to the elephant's face, let's twist a wire "tail" into the ring. Use the same method as for attaching beads, except that you'll want to use a thicker wire so the attachment will be more sturdy.

Press the monocle ring into the side of his trunk, in front of an eye (I picked his left eye for no real reason). Push until some of the ring imbeds into the clay.

If you want you can add a little ball of clay to cover the insertion area, which will make it a little neater.

Let the chain just drape away from the face, we'll attach it to the other side after it's baked (otherwise the chain keeps getting all over the clay and leaving marks). But, we do need to create something to link it to. If you have an eyepin, use that, otherwise use a bit of 20 gauge wire to make a loop connected to a wire twisty tail (just wrap the wire around a thin tool and twist).

Snip off the excess, bend a hook in the end.

Use some clay to make a ball and press it on the ear in a place where the chain will be able to connect in such a way that the loop will drape nicely. Now press the wire twisty loop into that ball. Tuck a small bit of clay through the loop and blend it into the circle if you want – I think it looks nicer that way. Don't attach the chain yet – that will come later.

How about a strap over the forehead? Yeah, that looks cool.

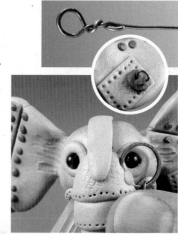

Now go nuts and add steampunky embellishments – a gear cluster on the opposite ear from the monocle side of the face looks great. (Remember the 'rule of three' = details look good in arrangements of three. This goes especially well for adding steampunkery. A group of three gears/accents of varying sizes and heights always looks balanced and believable – as if it were a working mechanism.)

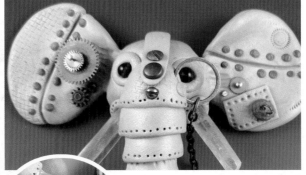

Brads and screws on the forehead, impressions of gears onto the clay of the ear – whatever you think looks good!

You can leave him just like this, but it looks really cool to add silver mica powder and metal him!! Brush a thick coating of powder all over! (ok, well, almost all over, I left some of the ears unpowdered, just for funsies).

Doesn't he look cool? (And wait til the patina – all those details are going to pop!!)

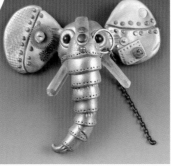

Time to bake. While the oven is preheating to the usual temperature, prop up any needed areas with little wads of tissue paper - under the tusks, under the monocle to hold it straight, behind the upper ears to hold the folds in position.

Bake for the usual time. Let him cool completely.

Now add the patina. Dark brown over all to bring out the details, and make the metallic mica powders look more aged. Let that dry, then use the reddish brown to add a rusty look – get the paint more dry and tacky by brushing it back and forth on a piece of paper to get rid of some of the moisture, thickening the paint. Then you can tap it on gently to mimic the powdery look of rust.

Nifty, huh?

Link the end of the chain to the loop using a jump ring (you know how!)

Once that's dry, you can add a pin backing to make this into a brooch. You can glue it on with epoxy or super glue. I prefer to sandwich the pin bar onto the back of the piece with liquid clay and a thin patch of fresh clay (it's more strong this way). Then rebake the piece for 25 minutes.

And now he's ready to wear!

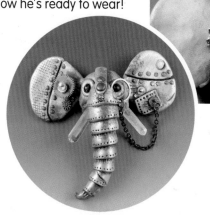

Sometimes a fella' needs a top hat…here's how:
Roll out a ball of clay and press it flat for the brim. Roll out a cylinder of clay. Press the top flat, pinch an edge all around. Slice off the bottom. Press the cut end of the cylinder onto the flat circle to attach. (If you want you can add a thin strip of clay around the base of the cylinder as a hatband.) Press the hat on the noggin and step out!

I myself have the 3rd largest top hat in the known world, specially constructed for me by Sheffields Haberdashery,

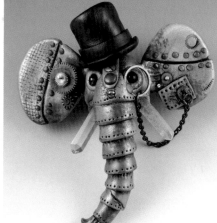

And the No. 1 Biggest Top Hat in the world is 47 feet tall, and belongs to the city of Cootamundra Australia.

Mr A. Lincoln, of the US of A has the 2nd largest hat (only fair, he is President)

GALLERY

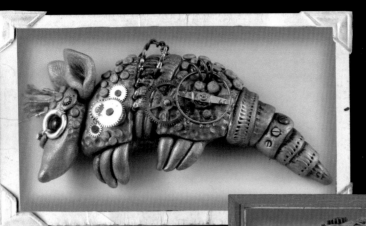

Armor-plated animals make great steam-punked creations like this armadillo. Of course armadillos aren't really armor-plated...

Or are they?

GUEST ARTIST: Kathy Davis
When you open up your heart and soul, who knew there would be so many wires in there!

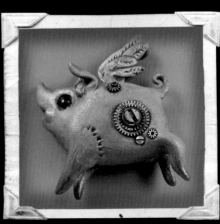

GUEST ARTIST: Sam Katz
Even crustaceans can go steampunk! This one has steam powered lasers.

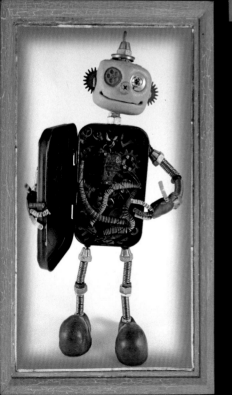

"When pigs fly" is not just an expression, it's reality! Um, I mean, it's not... it's just a little bead.

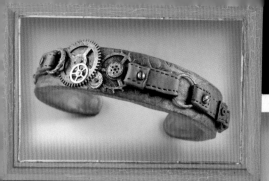

GUEST ARTIST: Heather Dada

This bracelet is a wonderful combi-nation of straps and gears. Wear one on each wrist to be a Steam-punk Superhero!

Those little brass thingys on his back are really steam-powered propulsion packs. Honest.

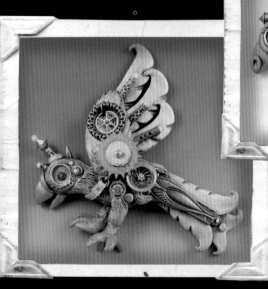

Birds have a lot of details that are wonderful to steampunk, as you can see. If you'd like a detailed step-by-step of how to make a steampunk bird, there's one in my book "Birds Of a Feather" (see p. 95 for more).

To make the gears seem functional almost as if they would work to power the piece), place them in logical places like the shoulder and thigh, and group several together, of varied sizes.

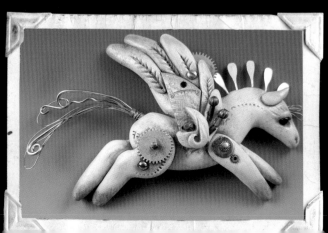

Since many of the projects in this book are focal beads, I think it might be a good thing to talk about stringing for a minute, since many of those beads will end up being strung up into a necklace.

Of course, any number of beading techniques can be used, but let's explore some more interesting steampunkish stringing ideas - such as chains! Chains go perfectly with steampunk! Obviously with the metallic colors in the clay and all the metal accents, your steampunk beads are practically begging to be chained…. hmm, that didn't come out right.

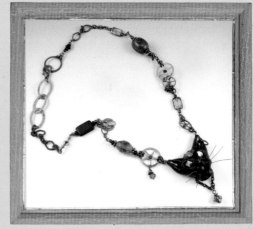

GUEST ARTIST: Cynthia Lohry

Chains come in all kinds of sizes and flavors.

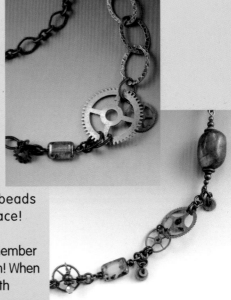

Don't forget to look in your old jewelry drawer for that jumbley pile of tangled necklace chains and re-purpose some of those. Don't worry if you only have parts and pieces of chain – connecting several sizes and styles of chain to make a necklace looks great. Add some gears linked in between the chains, and a few antiquey- looking glass/gemstone beads and you've got a really WOW necklace!

If your chains are new and shiney – remember you now know lots of tricks for aging them! When you're buying chain, look for the stuff with antique finishes whenever possible.

Thanks to Cynthia Lohry for these great examples of steampunk necklace assembly.

Linking all the bits and pieces together is easy. Just use jump rings to connect the pieces. Here's how – you'll need two pliers. Hold the jump ring with the pliers, one on each side of the split. Twist the pliers in opposite directions to open the ring. Slip the ends of the chains to be linked onto the jump ring, one on each side. Hold the ring with the pliers in the same way as before and twist the two halves back to center again to rejoin the link.

I suggest that you use two links in any area where you want to make sure the connection is strong. Just add a second link in the same way as the first.

If you're adding a gear or some larger link, just use a larger jump ring.

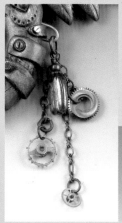

Use the same chain trick for dangles too, it can add movement and interest to a piece (I often leave a loop of wire exposed so that chains can be added later).

Closures are simple – any lobster claw clasp or circle & bar toggle will work beautifully, since they are metal, too. Remember to age them first if needed, so they will fit in with the rest of the look. Just link them in place in the same way.

Ok, so go and have some fun with chains!

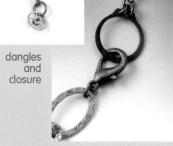

dangles and closure

Chains can be a main element in the design, like in this pendant.

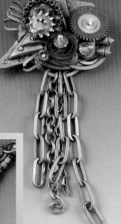

Chain can be used with other stringing materials such as beads, charms and ribbon.

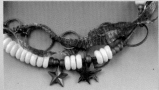

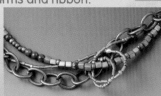

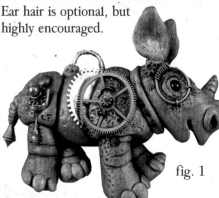
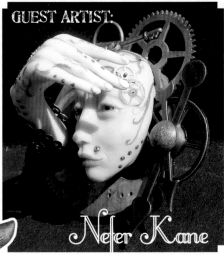

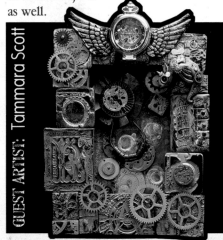

ADMIRAL GYROCOPTER'S
MENAGERIE
FANTASTICK STEAMPUNK BEASTIARY

MOSTLY HOUSETRAINED!

NEEDS A GOOD HOME!

DANGER! MAN-EATER!

YOU HAVE BEEN WARNED.

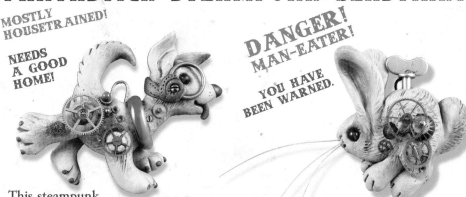

This steampunk pup has an enameled ring for a collar. I chopped his head off to slip it on, then blended the neck back together. As long as he doesn't sneeze, he's ok.

An old wind-up key is the perfect accent for this bunny. The cluster arrangement of the gears looks believable, doesn't it?

NO WOMBATS ALLOWED • ALLIGATORS $3 EXTRA

GUEST ARTIST: JULIE PICARELLO

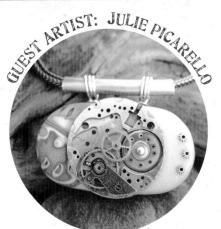

for that special someone on that special day.

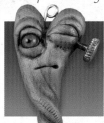

or for someone else on a different day. it's up to you.

An old windup key is the perfect steampunk accent to this cranky heart.

This is a beautiful example of just how interesting colors and patterns can be. The steampunk accents in the middle are intriguing on their own, but the addition of the patterned clay makes the whole piece come together beautifully.

GLOW-IN-THE-DARK STEAMPUNK BLOBS

Phosphorescent-tastic!

Look, there's just enough space for a little extra something fun!

FOR THIS PROJECT YOU WILL NEED:
- polymer clay: glow-in-the-dark
- assorted steampunk bits!
- mica powers

This is a super simple project and such silly fun – turn off the lights and watch him glow… that never gets old!

Roll out a ball of clay, then form it into a pill shape.

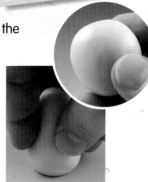

Press the pill onto a hard surface – smoosh it a little so it blobs out at the bottom. That way it will stand up easily.

Pull nubs out of each side of the head – they don't have to be symmetrical! Press the tips flat.

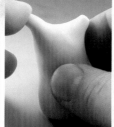

Stick steampunkery accents in the nubs! I had a little lightbulb and a weird brushy thing – but just about any thing that looks interesting would work.

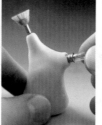

Eyes are easy – screws, headpins, little gears… anything eye-ish! You can make a nifty steampunk smile by pressing in the notched edge of a gear.

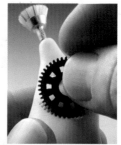

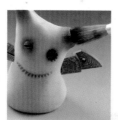

He doesn't need arms or wings – but if you have something that looks fun, jam them in there too! (I had some of those nifty engraved plates from vintage pocket watches that I used – they look devilishly angelic, huh?) Oh, and a dusting of powder here and there looks great!

TAH DAH!

Reminds me of the Tambooli Goblin who secretly steals my socks.

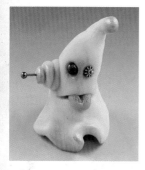
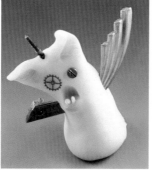
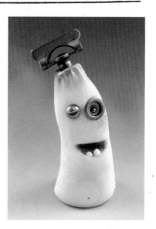

Here's more. All have different looks, but all made from the same steps. Fun, huh?

FINAL WORDS FROM WHATZHERNAME

Well, this is the end… of the projects (there's a bit more blither blather and info before we run out of pages in the book).

I love the steampunk look. It really gets my creative gears turning. I'll bet yours are cranking now, too - I can smell the smoke…

FROM THE DESK OF PROFESSOR CONTRAPTION

Well, looks like this is the end for me as well. Parting is such sweet sorrow. Cake is pretty sweet too, and speaking of which, I think I shall help myself to a generous slice in recognition of a job well done. It was fortunate that I could be here for you.

You're welcome.

Sincerely,

Professor Maximillion Contraption

Some of this stuff is mentioned in the projects of the book, but here's all the stuff you need to know about polymer clay, all in one place.

Polymer clay is wonderful stuff. It's probably the best art medium ever. It's versatile, lightweight, colorfast, accessible, user-friendly and probably some other interesting adjectives as well.

There are several brands of polymer clay – all of them are wonderful, and each has different properties that make them a good choice for different kinds of uses. I use and highly recommend Premo brand polymer clay for all the projects in this book – it's a wonderful clay for sculpting. Not too firm, not too soft, and it bakes into a strong, durable finished product. I love the stuff!

You should condition polymer clay before using it – simply roll, fold, twist and smoosh until it is soft and pliable (or for faster results, use a pasta machine/clay conditioning machine -- roll the clay through the rollers, fold and roll again and again until soft). As clay ages, it may lose some flexibility, but there are several products available to restore flexibility, such as Sculpey Clay Softener, Sculpey Mold Maker/Clay Conditioner and Translucent Liquid Sculpey. If you use another brand of clay, look for similar products in their line.

When you aren't using it, you can store polymer clay in glass jars or in most brands of plastic zippered bags, or wrap it in wax paper.

Store polymer clay in a cool place – clay left in the sun or some overly warm area will harden and get crumbly. Ick.

Any tool made from metal, wood or plastic works fine with clay. Fingers are great tools. Remember to clean your hands when switching from one color clay to another, if there is residue of clay on them. Clean them well when you're done playing as well – baby wipes work well, as does any soap with grit in it. Polymer clay does not thin with water, so use the wipes first and then soap and water will finish the job. Or just wipe your hands on someone else's pants when they're not looking.

brass rose, lost wax method
artist: Carole Witt

All the beads, gears, metal bits, and other fun things that you add to the clay can be baked right into the clay – only things that would melt in the oven (like plastics) should be avoided.

Baking polymer clay is the most important part of the whole process. It's the easiest part, but very important. You could make the most amazing piece in the history of art, but if you underbake it and it falls apart, or overbake it and it burns, who will marvel at your awesomeness?

Polymer clay is baked in a regular oven in order for it to fuse and harden. While it is baking, the clay does produce fumes, which some people are sensitive to. And, with fumes of any kind, it is always a good idea to use adequate ventilation. Many polymer clayers have a separate oven used just for polymer clay baking - use a toaster oven or convection oven - electric or gas -- don't use a microwave oven. There is no specific brand of oven that is overwhelmingly better than any other for baking clay, just the bigger the oven the better. Keeping your clay in the center of a larger oven, away from the heating elements is safest.

Always, always, always have a separate thermometer inside the oven to gauge the accurate temperature! Oven temperature knobs are not to be trusted.

Premo clay is cured when the clay reaches 275°F all the way to the inside, allowing the entire piece to fuse. How long depends on the thickness of the piece - about 20-30 minutes for every quarter inch of thickness at the thickest part of the piece is recommended. Other brands of clay have slightly different specifications. For all the projects in this book, you can expect the pieces to be in the oven for at least 45 minutes to an hour.

Polymer clay has a "give" to it when cooked properly – it will bend, not break.

FURTHER INFORMATION THAT'S GOOD TO KNOW

Mixing a clay color blend
Use the same process as conditioning, just go slower and look at the clay after every pass through the pasta machine! I like to call these "lookit" blends because you have to lookit the clay each time and at some point you'll say "Lookit this cool color!"
1. Choose your colors (have fun and experiment with combos)
2. Squeeze them together slightly and run them through the pasta machine at the widest setting. Rip the sheet and stack it together like stair steps.
3. Fold the clay into a little present to yourself with the coolest colors on the top. Smoosh it flat with your fingers and run it back through the pasta machine.
4. Repeat! After one or two or three repeats of this process, you'll have the beginnings of a nifty blend. You can stop there, or…keep going for a bit more subtlety!

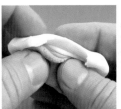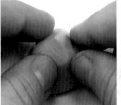

Making a 2-part silicon mold
There are a number of mold-making products available and each has instructions particular to use with that product. This is how to use a mini pre-measured mold kit (I have these available on my website cuz I love 'em!).
1. Have the item(s) to be molded ready to go, spread out on a flat surface (a piece of plastic like a sandwich baggie, or a square of wax paper is ideal). Some pieces might do well pressed onto a sheet of clay if there are cut-out sections of the original.
2. Open the cases and pull ALL the putty out of BOTH sections.
3. Press the two parts together and mix THOROUGHLY AND QUICKLY! You have less than one minute to mix before the silicon starts to set. The mix should become a light blue color with NO streaks of white or darker blue visible at all. The best way to mix is to fold and smoosh over and over, fast!
4. Immediately press the mix over the item to be molded, and cover it at least a quarter inch all around, and not more than about half an inch. Press all the way down to the flat surface.
5. Let it cure. It will take about five minutes to cure, then pop out the original. In ten minutes it will be hardened and ready to use!

Adding a hanging hook to the back

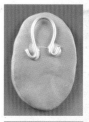

Usually this is added after the piece is baked (so the addition of the hook won't smoosh any of the front details).

1. After the piece has baked and cooled, turn it over (you can use a towel to cushion the front details).
2. Create a hanging hook by bending wire (20 gauge or thicker) into an arch and then bending each end of the wire back on itself.
3. Spread out a small amount of liquid clay in the area where the hooks will lay. Set the hook ends in the goop.
4. Roll out two balls of clay and press them over the liquid clay and wire ends. Press firmly to flatten.
5. Bake again (you can flip the piece onto its back again, it won't hurt the hanger) at 275°F (130°C) for at least 25 minutes.

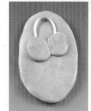

Once it's cooled you can pry the hanger forward slightly to hang on a nail or tack.

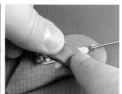

Adding a pin back for a brooch

This is also added after the piece is baked.

1. After the piece has baked and cooled, turn it over (you can use a towel to cushion the front details).
2. Spread out a small amount of liquid clay where the pin back will lay, as well as a little bit above and below.
3. Open the pin and lay the bar in the goop.
4. Roll out a little clay and flatten it. Lay it over the bar and press firmly to attach.
5. Add more flattened clay shapes until the bar is covered. They can be interesting-looking – it's more fun that way.
6. Bake again (you can flip the piece onto its back again, it won't hurt the hanger) at 275°F (130°C) for at least 25 minutes.

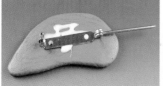
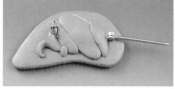

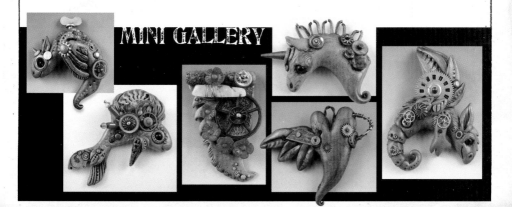

MINI GALLERY

Here are some of my favorite places to find the items I used in these projects.

. polymer clay, polymer clay supplies, inks, mica/embossing powders:
www.Sculpey.com
www.PolymerClayExpress.com
www.ClayFactory.net

**. mold-making supplies, tools,
metal-coatings/patinas, resins:**
www.Sculpt.com
www.RioGrande.com

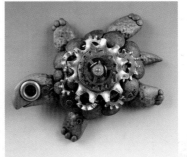

. Magic-Glos (UV-curing resin):
www.CoveredInClay.com

. beads, beading wire, tools, toggles, headpins, brooch pin-backs, glues:
www.FireMountainGems.com
(The best place to look first is your local neighborhood bead store!)

. stamps and texture sheets:
check the polymer clay resources for more, but the specific stamp I used in the floral project is a Dynasty Stamp from www.RioGrande.com - Aegean Stamp, "Argos" item #111849

. metal-aging fluids, patinas, coatings:
www.Sculpt.com
www.GildingTheLilyVintage.com (check out their safer alternatives for darkening metals)
www.Fundametals.net

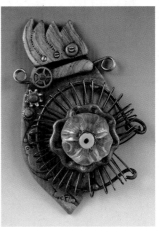

. vintage and reproduction vintage embellishments, steampunk gears:
www.Vintaj.com (the filigree piece in the Dragonfly project is a Vintaj piece: "Etruscan 2-hole" item# C2H60)
www.KabelaDesign.com
www.NunnDesign.com
www.SpecialtyBeads.com
www.Ornamentea.com
www.etsy.com/shop/SteampunkSupply
www.Metalliferous.com (the leaf I used in the floral project is from Metalliferous: "brass stamping/leaf" item# BR2029

. hard-to-find items (quartz crystals, enameled headpins, watch gears, lampworked glass eyes, mold-making kits):
www.CForiginals.com

These are just a few polymer clay sites you should know about!
www.NPCG.org (the International Polymer Clay Association site)
www.PolymerClayDaily.com (start your day with a dose of clay news)
www.PolymerClayCentral (all things polymer!)

My special thanks to these artists for letting me share their works.

Christi Anderson
www.ElementalAdornments.com

Darleen Bellan
www.DarbellaDesigns.com

Kathy Davis
www.kathndolls.com
www.flickr.com/photos/kathndolls

Sam Katz
samkatz1@earthlink.net

Nefer Kane
www.NeferKane.com

Tracey Lipman
www.TraceyLipman.etsy.com

Cynthia Lohry
www.HedgeHavenJewelry.com

Julie Picarello
www.yhdesigns.com

Dawn Schiller
www.autumnthings.com
www.oddfae.com

Eugena Topina
www.EugenasCreations.com

William Wallace
www.WilliamWallaceArt.com

Carole Witt
www.StringBead.com

Additional steampunkery from other fun folks is viewable online at my site:
www.CForiginals.com (click the 'gallery' button. go on... click it.)

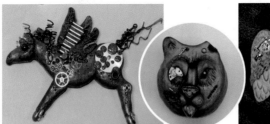
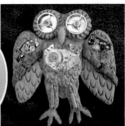

Shaun Mullin
www.Bogshaun.com

Christy Minnis
www.shouting-
stones.com

Kathy Penovich
kapenovich@comcast.net

Here's another cool steampunk book you should know about!
'Steampunk-Style Jewelry: A Maker's Collection of Victorian, Fantasy, and
Mechanical Designs' by Jean Campbell

Polymer Clay & Mixed Media: Together At Last
160 project-filled pages combining polymer clay and all kinds of other nifty things like fiber, beads, metal findings.

Dragons
Book 1 of the CF Series. 50 pages. How-to make an awesome dragon bead, and suggestions on how to make lots of other awesome dragons.

Welcome to the Jungle
Book 2 of the CF Series. 50 pages. Leaves! Flowers! A sloth and a tree frog! Step by step jungley projects.

Under the Sea
Book 3 of the CF Series. 50 pages. Create an ocean commotion with these projects - fish, seahorses, starfish, sea turtles and more.

Cats: Big and Small
Book 4 of the CF Series. 50 pages. Meow! Cute cuddly kitties and grand big cats in project form. They're grrrrrrreat!

Down Under
Book 5 of the CF Series. 50 pages. G'day mate! Come for a clay-filled tour down under and a host of Australian-themed mixed media projects. Vegemite optional.

Birds of a Feather
Book 6 of the CF Series. 50 pages. Techniques and ideas abound in these bird-themed projects. Create a nosey toucan, a flamboyant flamingo and more!

And they all
lived steampunkily
ever after.

The end.